Flushing
1880–1935

POSTCARD HISTORY SERIES

Flushing
1880–1935

James Driscoll for the Voelker Orth Museum,
Bird Sanctuary, and Victorian Garden

ARCADIA
PUBLISHING

Published by Arcadia Publishing
Charleston, South Carolina

Printed in the United States of America

Library of Congress Catalog Card Number: 2005925428

For all general information contact Arcadia Publishing at:
Telephone 843-853-2070
Fax 843-853-0044
E-mail sales@arcadiapublishing.com
For customer service and orders:
Toll-Free 1-888-313-2665

Visit us on the Internet at www.arcadiapublishing.com

CONTENTS

ACKNOWLEDGMENTS

The Voelker Orth Museum would like to thank those who volunteered their time, archival collections, knowledge of the area, and talents for making this book a reality. The historian Vincent Seyfried contributed his collection of postcards, the Queens Borough historian Stanley Cogan lent his collection of slides of old Flushing, and Victor Annaloro added his extensive collection of maps and postcards as well as his knowledge and enthusiasm for his native Flushing. We wish to thank Mary Callinan, the archivist-librarian of the Voelker Orth Museum who tirelessly sought out photographs and information about neighborhoods and houses of worship. Mary was indispensable in organizing the materials, proofreading, and keeping the project on time. Our thanks also to Pat Dillon and Lucy O'Gorman for contributing old photographs, to June Brown for the historical material concerning the congregation Temple Gates of Prayer, to Arlene Cusumano for her support, and to Gloria Lomuscio for proofreading and putting the book together. This project was introduced by Catherine Abrams, the director of the museum, who worked with the publisher and oversaw the project from beginning to end. Our greatest thanks and appreciation goes to Voelker Orth Museum's historian, James Driscoll, who wrote the text of the book. It is his unrelenting energy and incredible knowledge of the history of Flushing that makes *Flushing: 1880–1935* a compelling book to read.

INTRODUCTION

Before Queens County became part of New York City in 1898, Flushing was the name of one of its three western townships, along with Jamaica and Newtown, as well as the name of a village at the western end of the town. Some of the other villages within the town included College Point and Bayside. The village of Flushing was strategically located along Flushing Creek and near Flushing Bay. In the beginning, access to Manhattan, which is about 10 miles away as the crow flies, was relatively easy, first by water and later by road and ferry.

The village has a long, interesting history. It is the oldest continuously settled area in Queens County and, during the Colonial era, played a significant part in the struggle for religious freedom in America. During the Colonial era, its interesting horticultural heritage began. The first commercial nurseries in North America were started in Flushing. This helps explain why the village was long regarded as one of the prettiest on Long Island.

Flushing today is, of course, a very different looking place. It is a mixture of the urban and suburban, and it is impossible to say where Flushing begins or ends and a neighboring community starts. Since the mid-19th century, Flushing has been regarded as a somewhat ethnically diverse community because many European nationalities, as well as a large African American community, were represented in its census. Today it is considered one of the most ethnically diverse communities in New York City. People from many Asian and Latin American nations have settled in Flushing in recent years.

Through the use of postcards, mostly from the early 20th century, this book attempts to capture what one might call the old Flushing. The dates chosen for the book are the 17th century to 1930. The selection of 1930 is not an arbitrary one. Around this time, Flushing became part of the New York City transit system with the arrival of the No. 7 line. This would rapidly escalate the development of the area, a development that would skyrocket after World War II when nearly all the buildings that were left of old Flushing would disappear.

The Voelker Orth Museum is a new museum that was established in one of the old surviving homes from the late 19th century. Its mission, in part, is to educate the public on the history of the community. This is needed now more than ever, as more and more of the people moving into the community have virtually no knowledge at all of the wonderful history of the community they now call home.

One

EARLY HISTORY OF FLUSHING

The first settlers in Flushing were a group of English men and women who sought and were granted a patent to an area along the north shore of western Long Island by Gov. Willem Kieft of New Amsterdam in 1645. These first settlers did not come directly from England but had previously settled in New England. Many had lived in the Massachusetts Bay Colony but had found the Colonial government there to be increasingly intolerant; others came to Flushing because they thought the land would be better for farming than the rocky soil of New England. The land they settled on was already named Vlissingen on coastal charts drawn by the Dutch (Vlissingen is the name of a Dutch town). It is believed that the name Flushing is an English corruption of the Dutch name.

Conflicts developed between the English settlers and the rulers of New Amsterdam over religious freedom. The 1645 patent gave the settlers the same amount of religious freedom found in Holland, then the most liberal state in Europe in that regard, but this meant little to the governors of New Amsterdam. Real trouble developed when Peter Stuyvesant took control of the colony. He assigned an English cleric named Frances Doughty to take care of the religious needs of the people of Flushing in the early 1650s. Stuyvesant liked Doughty's religious teachings, which were similar to those of the Dutch Reformed Church, but the people of the town did not. Eventually, Doughty left the town. When the people of Flushing welcomed an early Baptist preacher named William Wickendam this infuriated Stuyvesant, who ordered Wickendam banished from the colony.

More serious trouble developed with the arrival of the Quakers on Long Island. Stuyvesant warned all the people throughout the colony that they were not to open their homes to any member of the Society of Friends. The people of Flushing objected, saying that this violated the patent that created their town, and in December 1657, many of the citizens of the town met and signed a document that came to be known as the Flushing Remonstrance. It argued for the idea that in America there was the call for separation of church and state, saying how an individual worshiped God was his private affair and that the state had no right to interfere. It was one of the first public statements defending freedom of religion in American history.

The people of Flushing were arguing for the rights of all men and women, and the people who signed the Flushing Remonstrance were not even Quakers. In the following years, many people in Flushing did join the Society of Friends. Stuyvesant, in spite of the Flushing Remonstrance, did not relent in his opposition. In 1661, when he heard that John Bowne, who had joined the Society of Friends at the urging of his wife, had allowed the Quakers to use his home as a meetinghouse, he had Bowne put under arrest and imprisoned in New Amsterdam. He then banished Bowne from the colony. Bowne went to Amsterdam in Holland to argue his case before the governors of the West India Company, the owners of the colony. They basically agreed with Bowne and issued an order preventing any further persecution of the Quakers by Governor Stuyvesant. This had little effect, because shortly after Bowne returned from Holland, the British seized control of New Amsterdam and renamed it New York.

In 1672, George Fox, the founder of the Society of Friends, visited Flushing. Fox spoke to the people of the village beneath two oak trees, near the Bowne House, which came to be known as the Fox Oaks. In 1702, an Episcopal church—today St. George's—was established in the town. Since Flushing was now part of an English colony, this was in effect a state-supported church; however, the Quakers would remain the dominant group in Flushing throughout the Colonial era.

The Quakers and the Episcopalians would be the only two religious congregations in the town until the early 19th century when the Macedonia African Methodist Episcopal Church was established. From the earliest days, there was an African American population in Flushing, in part because slavery was legal throughout the 13 colonies and, outside of the South, was most popular in the New York colony. One of the earliest steps toward abolishing slavery in New York was taken in Flushing. At its 1774 yearly meeting, the Society of Friends ruled that a Quaker could not own a slave and remain a member of the society. The sympathy of the Quakers to the cause of abolition made Flushing an attractive place for African Americans to settle.

This action was no doubt influenced by the revolutionary ideas in the air in the 1770s, but all of Queens, including Flushing, played little part in the Revolution since the county was occupied by the British throughout the war. Most of the town's residents remained neutral or were Tory sympathizers. One notable exception was Francis Lewis, a resident of nearby Whitestone, who belonged to the congregation of St. George's and had served as its church warden. He was a delegate to the Second Continental Congress in Philadelphia and became the only Queens resident to sign the Declaration of Independence. In retaliation, British troops burned his home and briefly imprisoned his wife. With the end of the Revolution in 1783, the British troops withdrew, and Flushing returned to being the sleepy village it was before the war.

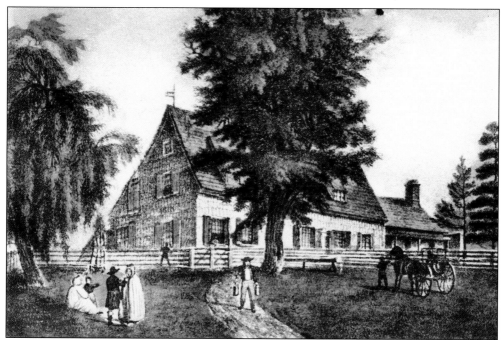

This mid-19th-century painting shows the Bowne House and part of its surrounding farm. Even then the home was locally revered because of John Bowne's struggle with Peter Stuyvesant over the issue of religious freedom. Much of downtown Flushing east of Main Street was once part of the Bowne farm. Most of the farmland was subdivided into lots and sold in the 1840s.

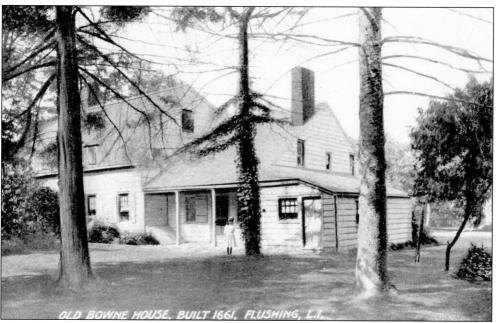

OLD BOWNE HOUSE. BUILT 1661. FLUSHING, L.I.

This more recent photograph shows the smaller rear portion of the Bowne House. Used to house the kitchen, it was once thought to be the oldest section of the house. Recent archaeological work reveals that it was the last section of the house to be built, possibly as late as 1800. The eastern section of the main house was built in 1661 and was expanded in the 1690s.

11

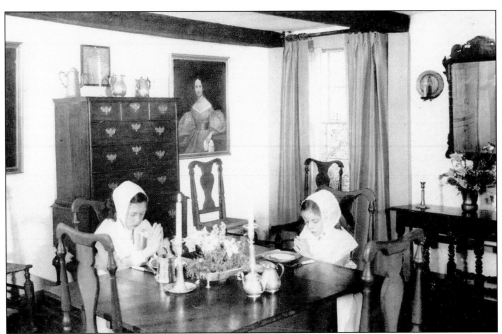

This is a postcard published by the Bowne House Historical Society. The picture shows two children dressed in Colonial attire sitting at the dining room table and was probably issued in the 1950s. The Bowne family turned ownership of the home over to the historical society in 1945. Nearly all the items (furnishings, paintings, and so forth) found in the home belonged to members of the family, who occupied the home continuously for nearly three centuries.

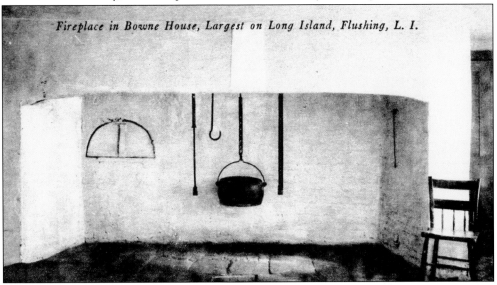

Fireplace in Bowne House, Largest on Long Island, Flushing, L. I.

Another society postcard, this one shows the Colonial fireplace in the kitchen wing. This part of the house was long popular with local school groups who had visited the Bowne House for years. It is believed that the house served as a station on the Underground Railroad; although, old stories about a tunnel beneath this section are no longer thought to be true. Unfortunately, because of the need for extensive restoration work, the Bowne House has been closed to the public for years.

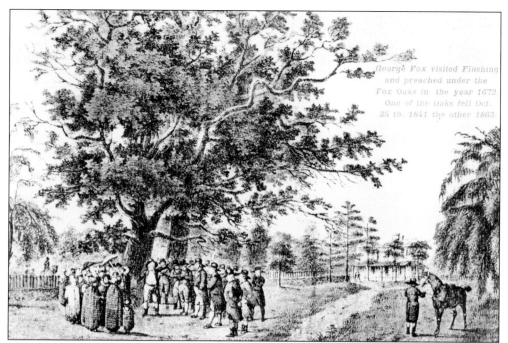

This sketch shows George Fox, the founder of the Society of Friends, speaking to fellow Quakers in Flushing in 1672. He is shown speaking beneath the two oak trees that were later called the Fox Oaks. The Bowne House can be seen in the background to the right.

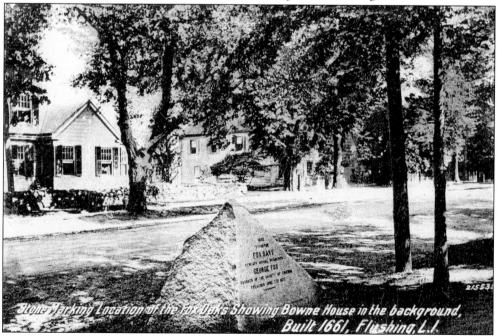

Both of the Fox Oaks were gone by 1863, so in 1895, the Society of Friends erected this stone monument marking their location. It is still there, on the west side of Bowne Street in front of an apartment building and across the street from the Bowne House, which can be seen in the center background.

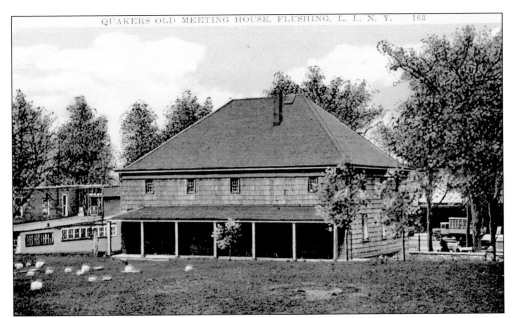

The Flushing Quaker Meeting House was built in 1695 and is the oldest house of worship in New York City. It is still the home of an active meeting and can be found on the south side of Northern Boulevard. The front of the building faces south, away from the busy street, and can be seen in this postcard along with a portion of the burial ground. It is believed that John Bowne, one of the builders of the meetinghouse, is buried in this cemetery.

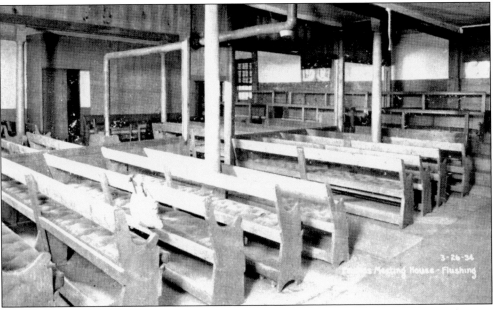

The interior of the meetinghouse exemplifies the simple style found in Quaker meetinghouses. Today the interior looks pretty much the way it looked in the 18th century. With the exception of the period of time when it was used by the British for various purposes during the Revolution, Quakers have continuously held services here for over 300 years. The Quaker meetinghouse and the Bowne House are both New York City landmarks.

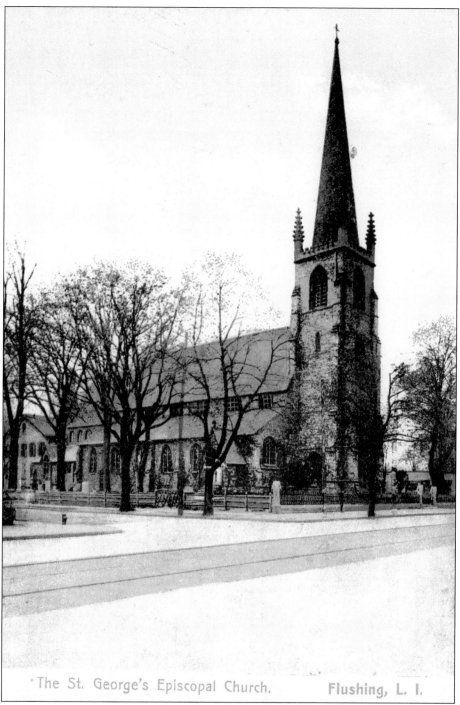

The St. George's Episcopal Church. Flushing, L. I.

This is the third church building erected by the St. George's Episcopal Church. It was built in 1854 and is located on Main Street, on the same site as the original church building. In the vestibule of this building is a marble plaque honoring Francis Lewis, a signer of the Declaration of Independence and onetime church warden. There were patriots in the Flushing area when the Revolution started, but many of them fled when the British took over the area.

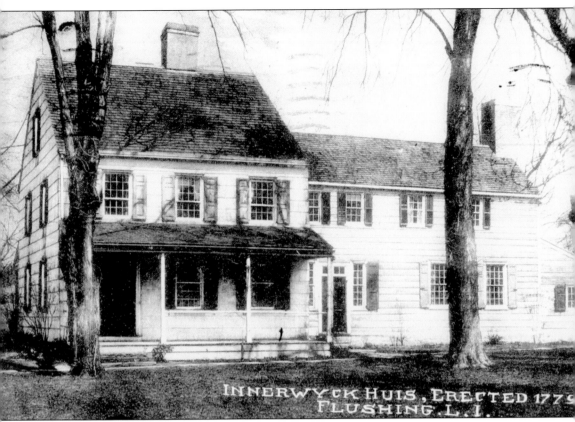

INNERWYCK HUIS, ERECTED 1779
FLUSHING.L.I.

Innerwyck was once the home of Col. Archibald Hamilton, the leader of the Tory faction in the town of Flushing and, according to contemporary accounts, a man despised by all. He left America for England shortly after the end of the Revolution. Many of the other Tories on Long Island migrated to Canada after the war. Innerwyck survived until the 1950s, when it was torn down. It was located a couple blocks north of Northern Boulevard.

Two

FLUSHING'S HORTICULTURAL HERITAGE

Around 1735, Robert Prince and his son William started the first commercial nursery in the United States on land bordering the Flushing Creek near today's Northern Boulevard. According to old traditions, the Princes learned much about grafting, and other necessary skills, from earlier French Huguenot settlers who lived in the area for a short time in the late 17th and early 18th centuries. The Prince family, like many who had settled in Flushing, had migrated into the area from Massachusetts. Their nursery was so successful and highly regarded that during the American Revolution the British stationed troops around it to prevent it from being looted.

After the Revolution, the nursery's fame continued to grow. Pres. George Washington visited the nursery in 1790. He traveled out from Manhattan, the site of the nation's first capital, with Vice Pres. John Adams. According to Washington's diary, they were not too impressed. The following year, Secretary of State Thomas Jefferson visited, and he liked what he saw, ordering many plants that were later shipped to his home in Virginia, Monticello. This was easy for the Princes to accomplish since they were near a dock on the creek, called Flushing Landing, and boats traveled regularly to the piers in lower Manhattan, where plants and trees could be shipped to Virginia. The completion of the Erie Canal in 1825 made it even easier to ship plants.

Robert's grandson William ran the nursery in the early 19th century and moved part of it to land north of Northern Boulevard and renamed it the Linnaean Gardens, in honor of the Swedish scientist who developed the plant classification system. The nursery's fame continued to grow, and it became something of a tourist attraction. People living in Manhattan would travel out to Flushing for the day to see the beautiful plants Prince was importing from all over the world. The nurseryman offered rewards to ship captains who traveled to European and Asian ports for bringing him exotic plants. Around 1800, William Prince decided to improve business even more by building the first bridge over the Flushing Creek. This made it much easier to travel by road to Manhattan and not only expanded the nursery business but ended the village's somewhat sleepy, isolated existence.

William and his son William Robert became well-known writers on horticultural subjects. However, not all their efforts succeeded. They imported mulberry trees to help develop silkworm

farms in the area, but that proved unprofitable, and William Robert's efforts to grow wine-producing grapes, after initial success, were destroyed by disease.

By the early 19th century, other competing nurseries opened in Flushing. One of the most famous was the Bloodgood nursery. Its founder, James Bloodgood, was a talented horticulturalist who developed a type of Japanese maple called the Bloodgood maple that is still sold by nurseries today. This nursery was sold to the King and Murray families, who would operate it from the 1840s to the end of the 19th century. Maybe the most famous of the later nurseries was the Parsons nursery, which occupied the land that is the site of today's Flushing High School and Weeping Beech Park. Begun in 1838, it too was famous for importing plants from all over the world, including the famous weeping beech tree, which was brought from Belgium in 1847. Members of the Parsons family would work with Frederick Law Olmsted and Calvert Vaux in the landscaping of Central Park in Manhattan and Prospect Park in Brooklyn.

As the village continued to grow and real-estate prices started rising, the early nurseries started disappearing from Flushing. The Prince nursery was gone by 1870, and the others were gone by the early 20th century. The Parsons nursery survived, dividing itself in two in the early 1870s. One brother, Robert, kept the old nursery in downtown Flushing, which was eventually sold off piecemeal for real estate, and the other brother, Samuel, started a new nursery, which he called the Kissena nursery, about a mile from the downtown area. This only survived until the early 20th century, when much of it was sold to the city and became a part of today's Kissena Park.

Even if all the old nurseries are gone, there are still some reminders of Flushing's horticultural heritage in the area today. Many of the village's streets were lined with beautiful trees, some of the older ones planted by the old nursery families. As the village expanded, a custom developed of naming the new streets alphabetically after trees and plants. They extend from Ash to Rose. Rose Avenue runs right along the northern edge of Kissena Park where there are some nursery rows, which are remnants of the old Parsons nursery.

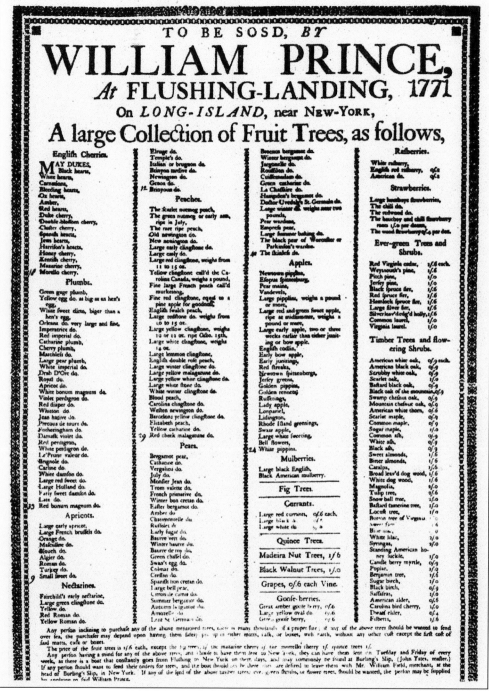

A one-page catalogue was produced by the Prince nursery in 1771. It lists all the different plants and trees that could be purchased at the Flushing nursery. Apple trees were particularly popular. One type sold was the Newtown pippin, an early and popular type of apple that was accidentally developed in the neighboring town of Newtown.

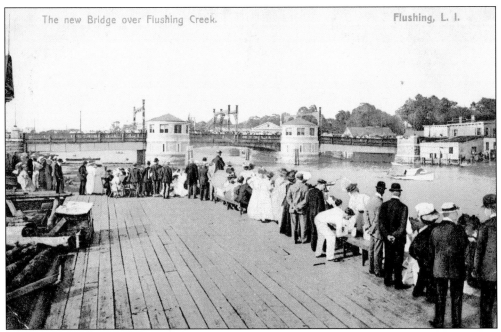

This picture of the town dock was taken many years after the heyday of the Prince nursery. Regularly scheduled boats brought its trees and plants from Flushing to lower Manhattan. Most of the major nurseries had agents in lower Manhattan who arranged shipments all over. William Prince built the first bridge over the creek about a hundred years before the more modern 1906 bridge shown in the picture.

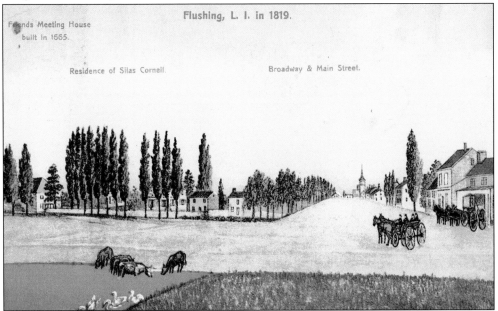

This painting was done by local school teacher Silas Cornel in 1819. It shows the old intersection of Broadway (now Northern Boulevard) and Main Street. Down Main Street is the old St. George's Church. The trees along Broadway to the left were Lombardy poplars planted by William Prince. This Italian tree was briefly popular in the United States until they were destroyed by a plant disease.

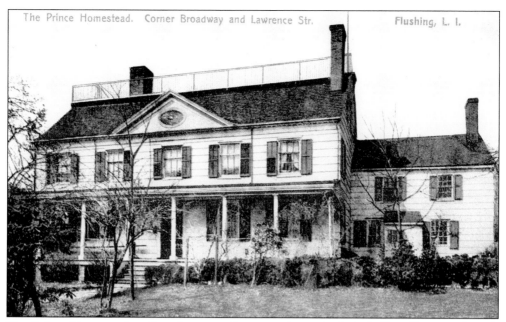

The Prince Homestead on Broadway near Lawrence Street (today's College Point Boulevard) is seen here. The Embree family built this home in the mid–18th century, and around 1800, it was purchased by the Prince family. The Linnaean Gardens were located on the lands behind this house. This beautiful landmark survived until the late 1930s, when it was torn down by developers, despite the protests of local preservationists.

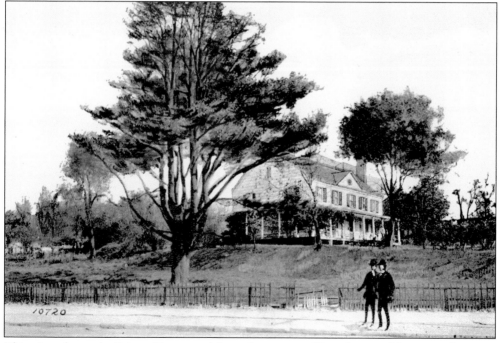

This view shows the Prince Homestead from the corner of Broadway and Lawrence Street. It shows some of the trees planted by the Princes, including a cedar of Lebanon in the foreground. Today this area of Flushing is commercial, as the home of small factories and lumber yards.

21

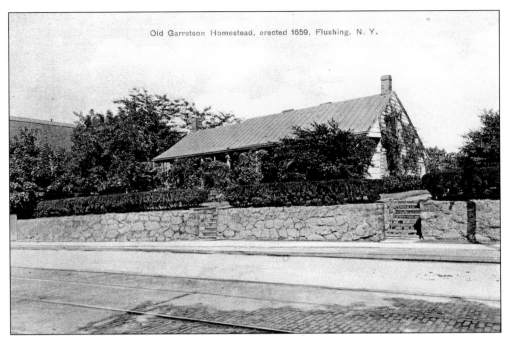

This was the Garretson House on Main Street, across the street from St. George's Church. It was torn down in the early 20th century. Its owner worked for the Prince nursery and then left to start a seed farm. The company produced one of the first seed catalogues in the United States.

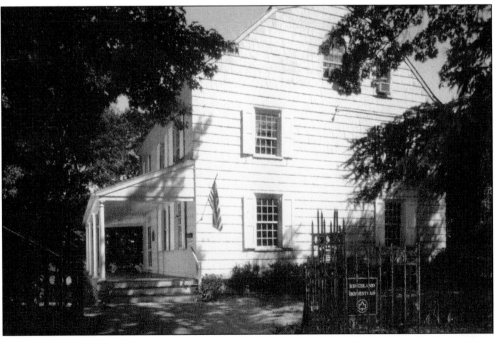

This is the Kingsland Homestead at its current location in Weeping Beech Park, the site of the old Parsons nursery. The King and Murray families, related by marriage, purchased controlling interest in the old Bloodgood nursery around 1840. They lived in Kingsland, and the nursery surrounded their home at its original location on Northern Boulevard near 155th Street.

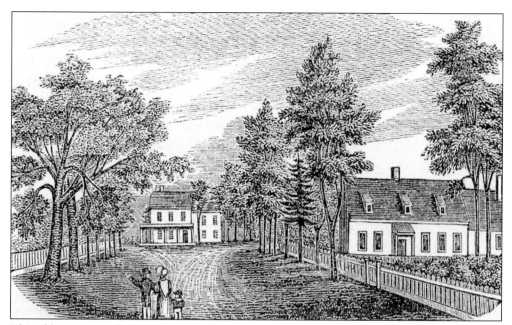

This old engraving shows Bowne Street in the early 19th century. To the left can be seen one of the most famous trees of old Flushing: the Fox Oaks. To the right is the Bowne House, and in the center at the head of Bowne Street is the home of Samuel Parsons, the founder of the Parsons nursery.

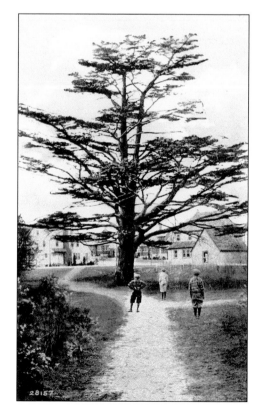

This cedar of Lebanon was located on land at the northern edge of the old village near Bayside Avenue. It was regarded in its day as the most beautiful specimen of this species in America and was much photographed. It survived until after World War II, when the storm-damaged specimen was taken down by real-estate developers.

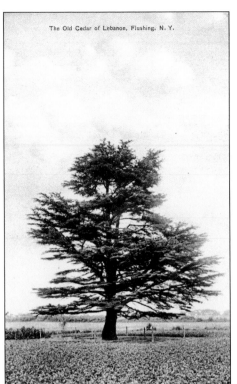

The Old Cedar of Lebanon, Flushing, N. Y.

This is an earlier view of the cedar of Lebanon. In this picture, it appears to be completely surrounded by farmland. It was actually located on land that was once part of the Higgins nursery. Daniel Higgins was another former Prince employee who started his own nursery. It is possible that Higgins may have purchased one of the specimens originally grown by the Prince nursery.

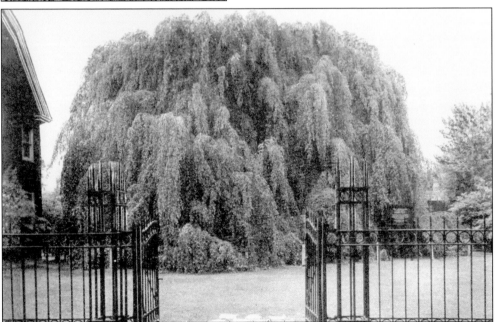

Another historic tree in Flushing that was widely known was the Weeping Beech Tree. The original planting was brought to Flushing by Samuel Bowne Parsons in 1847. It was brought from Belgium and planted on the grounds of the family nursery, which at that time was run by Samuel and his brother Robert Bowne Parsons. It was proclaimed the finest example of the weeping beech in America in the early 20th century. It was declared a New York City landmark in 1966.

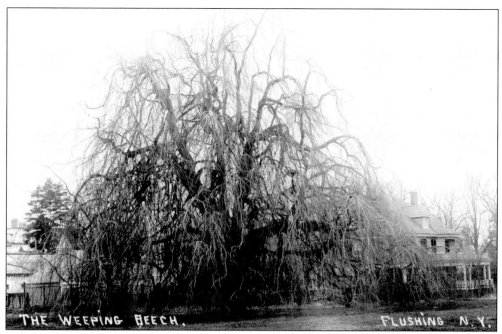

THE WEEPING BEECH. FLUSHING N.Y.

Seen here is a view of the Weeping Beech Tree in winter. Developers wanted to remove the tree and build an apartment building on the site in the 1920s. The Flushing Garden Club protested and asked New York City to save the tree and establish the site as a park. The city agreed, and today's Weeping Beech Park was born. The Garden Club was somewhat annoyed because they wanted the park to be named for the Parsons family. The Weeping Beech Tree died in 1997, but offspring of the original still occupy the site.

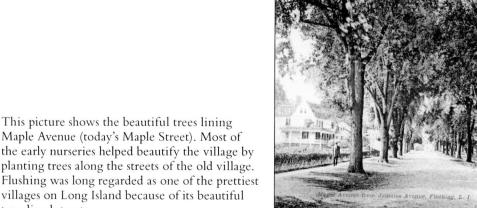

This picture shows the beautiful trees lining Maple Avenue (today's Maple Street). Most of the early nurseries helped beautify the village by planting trees along the streets of the old village. Flushing was long regarded as one of the prettiest villages on Long Island because of its beautiful tree-lined streets.

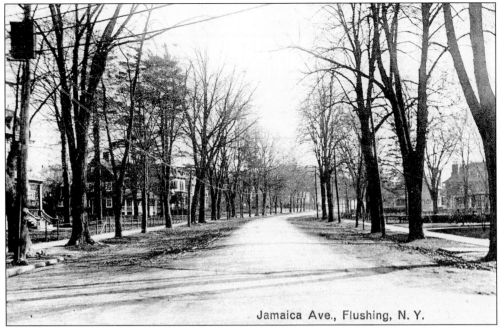

Jamaica Ave., Flushing, N. Y.

Another beautiful tree-lined street was Jamaica Avenue, which is today's Kissena Boulevard. It was called Jamaica Avenue in Flushing because it went from Flushing to downtown Jamaica. In Jamaica it was called Flushing Avenue.

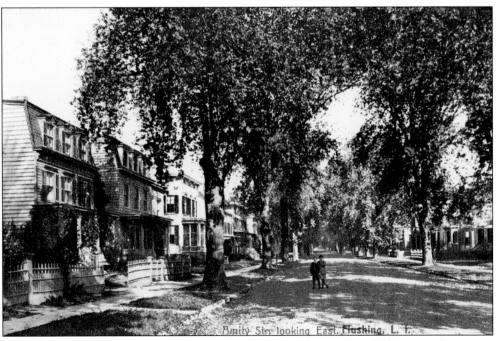

Amity Str. looking East, Flushing, L. I.

Another beautiful tree-lined street was Amity Street, which is today called Roosevelt Avenue.

Three

BROADWAY

The first settlers in the village of Flushing probably built their homes along a street originally called Broadway, which is now Northern Boulevard. This is part of Route 25, a road that travels along the entire north shore of Long Island. It is a very old road and was originally a Native American trail. In Flushing, the settlers probably built their earliest homes near the creek, although it is really not known. In the 1780s, the records of the Flushing town clerk were destroyed in a fire, so knowledge of the Colonial era is sketchy. Sometime early on, a second important street, Main Street, was developed, and the intersection of these streets was the heart of old Flushing.

The importance of Broadway increased dramatically with the opening of the bridge over Flushing Creek that William Prince had built in 1800. Since traveling by road to Manhattan was now somewhat easier, many well-to-do families started building country homes in the village, several of them along Broadway. With the opening of the bridge, the section of Broadway from the bridge to Main Street became known as Bridge Street.

On the north side of Broadway and the foot of Main Street since the Colonial days was a hotel that was eventually called the Flushing Hotel. Stagecoach service between Flushing and the Brooklyn ferries to Manhattan was begun in 1802. The stage stopped in front of the hotel until rail service took its place in the 1850s. The hotel was sort of the social center of the town. It was a place where visiting dignitaries would stay over and where the important social gatherings would take place.

The oldest building on Northern Boulevard is the Quaker meetinghouse, which was built in 1694. It is on the south side of the street, a short distance east of Main Street. The Episcopalians held their first services on Broadway in a building called the Guard House near Union Street. It served as a fort and a local jail in the Colonial era, and they used this building until they built their first church building on Main Street in 1746.

Any building that had to do with the village and the town government was built along Broadway. A village hall was erected on Broadway in 1841 on a mall island in the middle of the street near the Main Street intersection. It was totally inadequate to meet the needs of the growing village and town, so a town hall was opened in 1864 on the north side of Broadway across the street from the Quaker meetinghouse. It was a place where the village and town boards could meet and local justices could hold court. There was even a jail in the basement. It also had an auditorium where visiting performers and lecturers could entertain the local citizens. Frederick Douglass spoke at the town hall shortly before the end of the Civil War.

Shortly after the Civil War, a monument to the town's dead, an impressive obelisk, was erected on an island in the middle of Broadway, across from the town hall. It was probably around this time that the decision was made to extend a mall from where the old village hall was located farther toward the town hall. It was wider than the current mall, particularly at the Main Street end. The mall was known as Flushing Park. It was an actual park that had walkways, benches, beautiful landscaping, and a wonderful fountain near the Main Street intersection. Sadly, the park gave way to the automobile. By 1930, traffic congestion created a need for a wider Broadway (now called Northern Boulevard), and the mall was narrowed to allow more traffic on both sides. Even though the fountain did not survive this transformation, at least the Civil War monument did, along with a number of other subsequent war memorials.

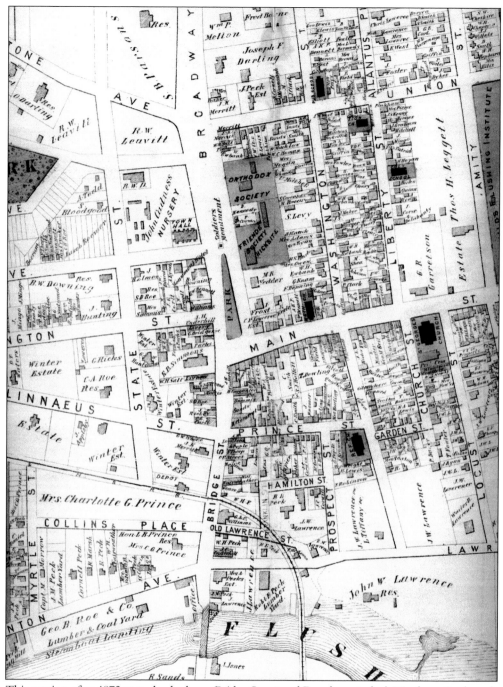

This portion of an 1872 map clearly shows Bridge Street and Broadway, today's Northern Boulevard.

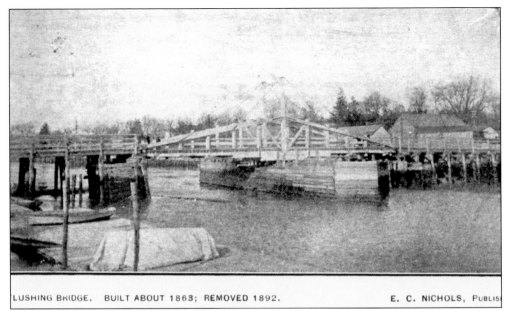

The building of a bridge over Flushing Creek helped open up the village of Flushing and increased the importance of Broadway. This is the earliest bridge over the creek of which a picture exists. This bridge was erected in the 1860s and was probably the third bridge built over the Creek.

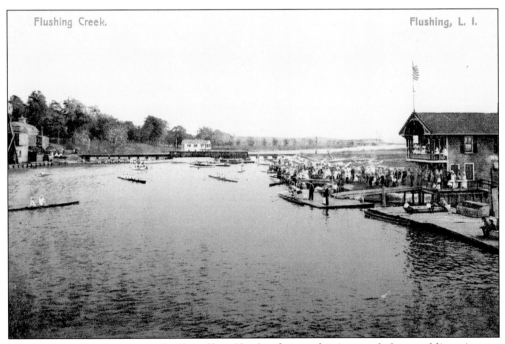

Flushing Creek. Flushing, L. I.

The Flushing Creek today is a badly polluted body of water that is regarded as a public nuisance. As late as the early 20th century, however, it was where people in the village went to enjoy the day. This picture, taken from the bridge, shows a boat race going on at the Wahnetah Boat Club. A Long Island Railroad trestle is in the background.

30

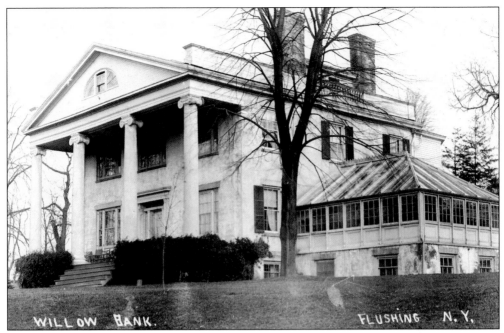

There were a number of beautiful homes along the Flushing Creek. This was Willow Bank, the home of the Lawrence family, one of the most prominent families in Flushing. This is a view of the front entrance. The home was just south of Broadway, near today's College Point Boulevard, which used to be called Lawrence Street.

This view of Willow Bank shows more of the land near the creek.

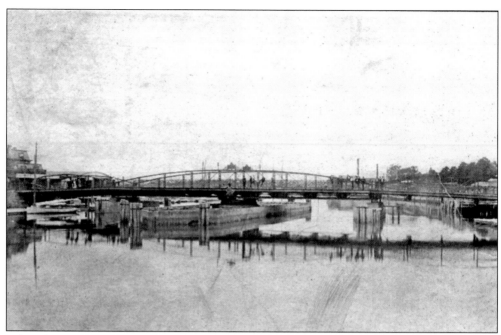

A later bridge over the creek is shown here. Like the earlier bridges, it was a turnstile bridge that would turn to allow boats to pass by. Commercial traffic on the creek was very important at that time, and the trolleys were coming to the village along Broadway.

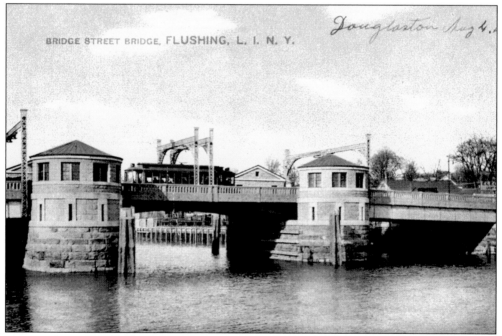

BRIDGE STREET BRIDGE, FLUSHING, L. I. N. Y.

Douglaston Aug 4.

In 1906, the opening of a modern stone drawbridge was regarded as a major event in the village. It accommodated more traffic, including the new automobiles, and, most importantly at the time, it was considered much safer for trolleys. It was also easier to open for boat traffic.

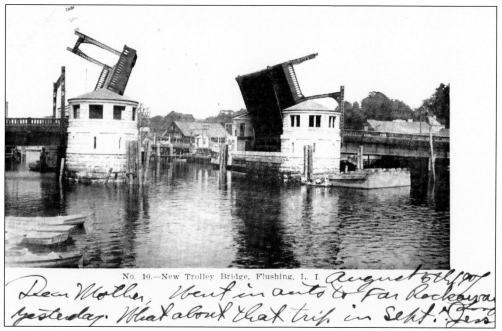

No. 10.—New Trolley Bridge, Flushing, L. I *August 5th/07*

Dear Mother, Went in auts & Far Rockaway yesterday. What about that trip in Sept.? Jess

This view shows the bridge raised to allow river traffic. In the 1930s, the length of the Flushing Creek was greatly reduced to allow for the world's fair in Flushing Meadows, and barge and boat traffic became less and less important.

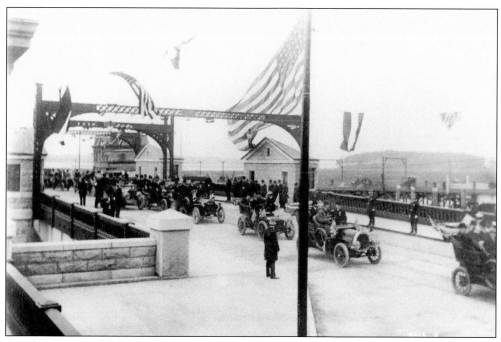

Seen here is the celebration for the opening of the new Flushing River Bridge.

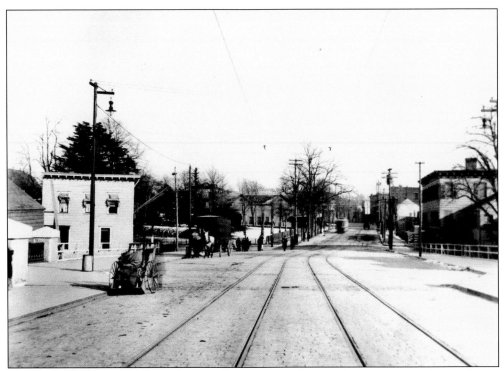

This photograph was taken from the bridge looking east along Bridge Street toward Main Street. The trolley tracks can be clearly seen. Trolley service survived until the 1930s. By this time, Main Street had become the major commercial street in the village.

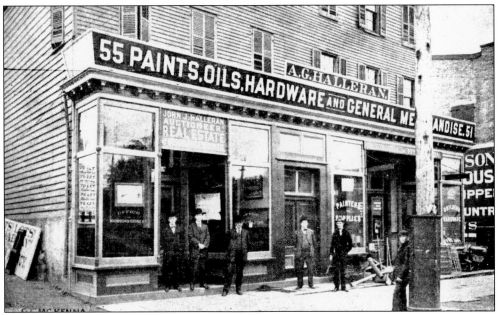

A typical retail store in old Flushing is seen here. This building was just east of Prince Street. One of the occupants was the Halloran Real Estate Agency, which played an important role in the development of Flushing.

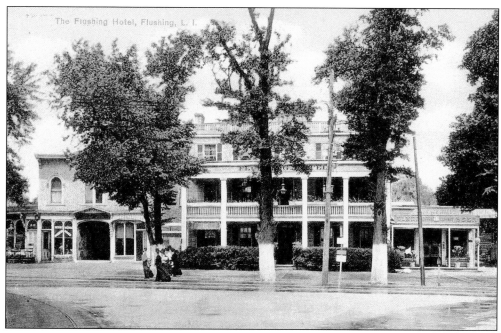

The Flushing Hotel is seen on Broadway, at the head of Main Street. This was the second hotel on this site, the first having burned down in the 1840s. For many years it was the social center of the village.

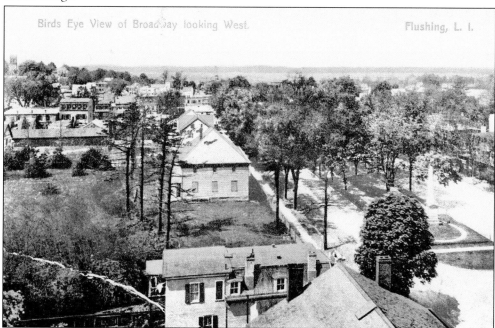

This is a panoramic photograph of Broadway looking west, taken from the roof of the armory shortly after it was open in 1905. The Flushing Creek is in the background. On the left can be seen the side of the Quaker meetinghouse. According to local tradition, the armory was built on the site of Michael Milner's house, where the Flushing Remonstrance was signed in 1657. The actual house was probably located nearer to the creek.

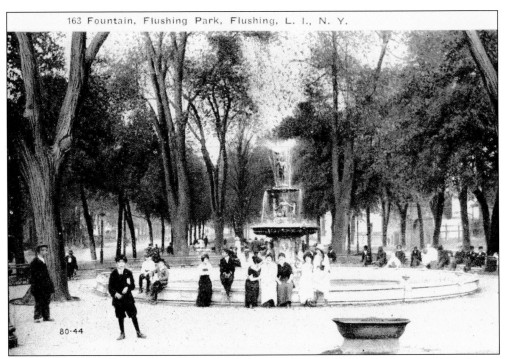

80·44

The beautiful fountain in Flushing Park was located near the intersection of Broadway and Main Street. Based on the styles of dress, this photograph appears to have been taken in the early 20th century. The photograph gives an idea of how wide the mall originally was. The fountain was destroyed when Northern Boulevard was widened.

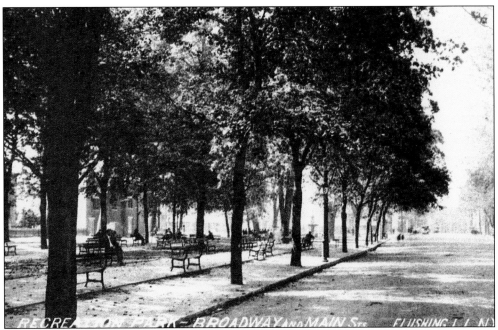

RECREATION PARK - BROADWAY and MAIN Sts. FLUSHING L I N Y

This is a photograph of the eastern end of the park looking west. The fountain can be seen in the background.

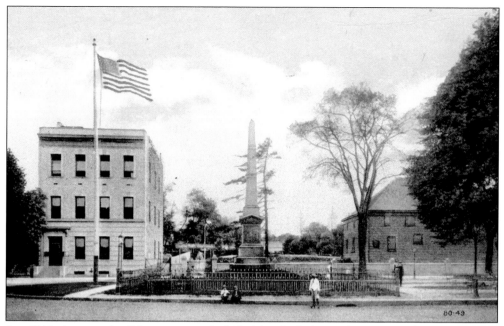

A *c.* 1915 photograph of the eastern end of Flushing Park shows the 1866 Civil War Memorial and, in the background, the back of the Quaker meetinghouse (the front of the building faces south). To the left is the newly opened telephone building. The monument and the two buildings are still standing.

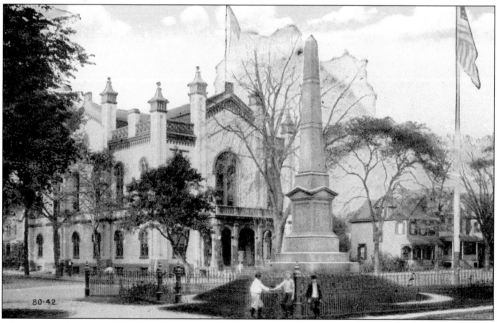

This view of the Civil War monument looks north. In the background is Flushing Town Hall. The hall opened in 1864. It became a social, as well as political, center of the town. It was the place where the village and town officials met and had their offices. It also had a large auditorium where many well-known entertainers and public figures appeared, including P. T. Barnum and Col. Tiny Tim.

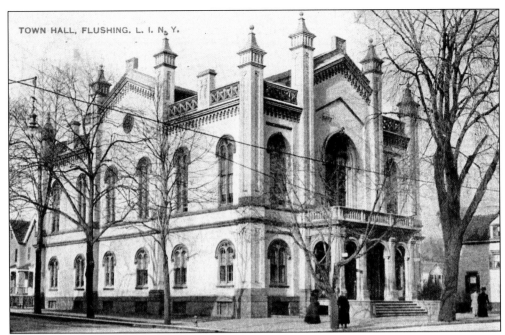

This is Flushing Town Hall in the early 20th century. The building is today owned and operated by the Flushing Council on the Arts. After Queens became part of New York City in 1898, the city used the building as a municipal court building. In recent years it was taken over by private owners. The council took control in 1990, and today the building is used for art exhibits, jazz concerts, and so forth.

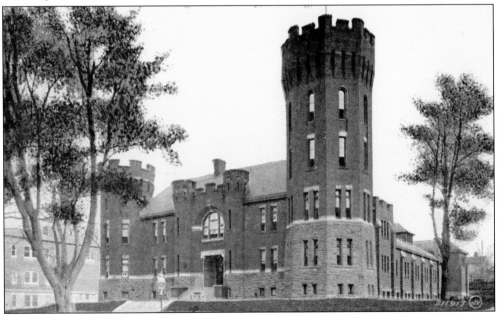

Quite common in other parts of New York City, this is the only castlelike armory to have been built in Queens. For many years, it was the home of the local National Guard units, and its drill floor was the site of local balls and high school proms. The armory was opened in 1905. Today it is used by the New York City Police Department.

This World War I monument stands in front of the armory. Another section was added to the mall to accommodate the memorial dedicated to the local men and women who lost their lives in the 1917–1918 war. It is the work of Hermonn MacNeil, who lived in nearby College Point and was a well-known sculptor at the time.

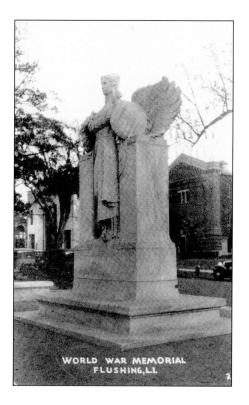

To the east of the armory is the Masonic hall (the Cornucopia Lodge). Flushing, like many small towns, had many lodge halls. The Odd Fellows hall was also on Broadway, nearer to Main Street.

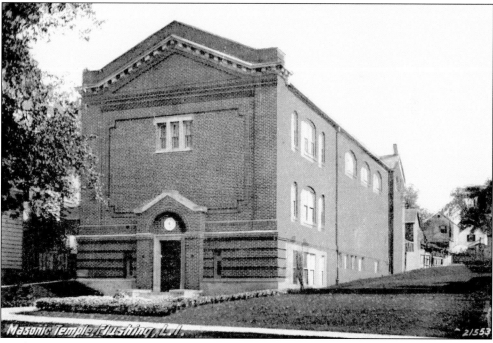

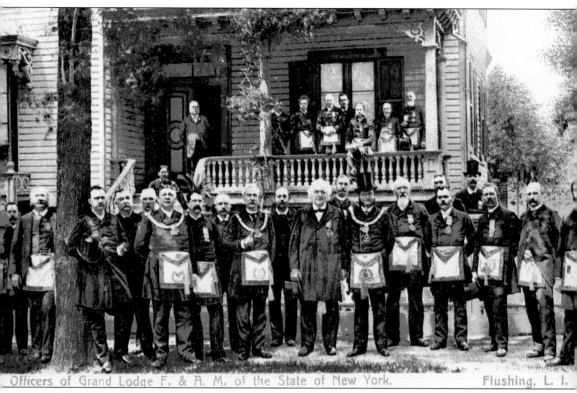

Officers of Grand Lodge F. & A. M. of the State of New York. Flushing, L. I.

This caption shows the members of the Cornucopia Lodge at their old lodge hall on Franklin Street shortly before they opened their Masonic hall on Northern Boulevard.

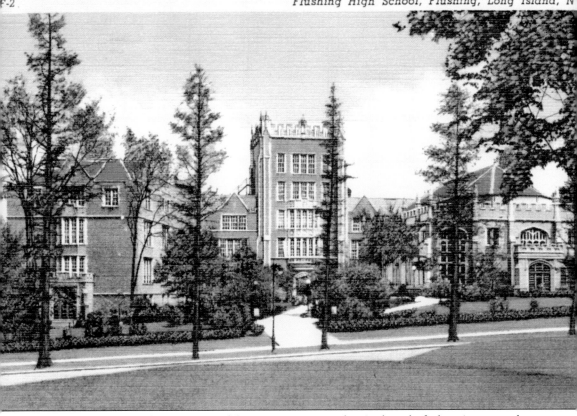

On what was the northern portion of the Parsons nursery, the city board of education erected a new Flushing High School building, beginning in 1915. This beautiful building, in the collegiate Gothic style, is a New York City landmark. The bald Cyprus trees in front of the building are still standing.

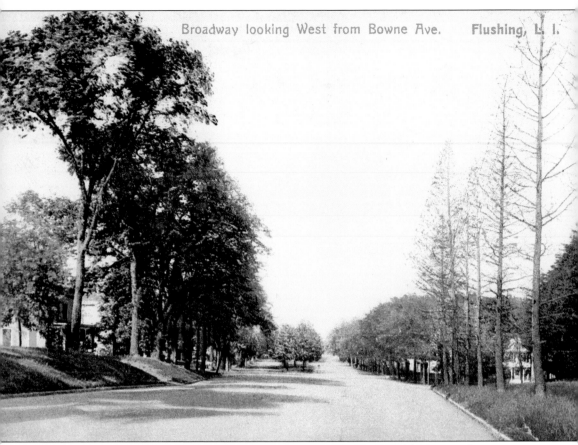

Broadway looking West from Bowne Ave. Flushing, L. I.

This is the view looking west on Broadway from Bowne Street, a block east of Union Street. The eastern end of the mall is visible in the background. The picture shows how residential Broadway was, east of Union Street, in the early 20th century.

Four

MAIN STREET

Most small towns in America have a Main Street, and Flushing was no different. It appears to have been the second street in the old village that was laid out. For many years, the area around the intersection of Main Street and Broadway became the commercial center of the village.

The first house built on the street was probably the Bloodgood House, which may have been older than the 1661 Bowne House. Later on, it was known as the Garretson House. For many years, it stood opposite St. George's Episcopal Church until it was torn down in the early 20th century. The decision to build the first Episcopal church on Main Street in the 1740s, a couple of blocks south of Broadway, probably did a good deal to increase the popularity of the street. However, as late as 1800 it was described as a hilly, dusty road with maybe a dozen buildings along both sides of the street.

With the building of the Flushing River Bridge, the village started to grow and more buildings started appearing along Main Street. Slowly the street became more commercial, particularly at the northern end near Broadway. The southern end of Main Street developed more slowly. For many years, the street virtually came to an end where the library is today. A much narrower street, Jaggar Street, was its continuation to the south. Intersecting with Main Street near this site was a street that is today called Kissena Boulevard but in the beginning was called Jamaica Road because it connected Flushing with the village of Jamaica, about five miles to the south.

The situation started to change in the 1860s with the coming of the Long Island Railroad to Flushing. The line would cross Main Street near the southern end of the street, and the original station would be at the site of the current station, Forty-first Avenue just off Main Street. The center of the village was slowly beginning to shift south. By the beginning of the 20th century, Main Street was made even more important by the arrival of the trolley. A trolley now traveled from Long Island City along Northern Boulevard, over the Flushing River Bridge, and then south along Main Street. With the opening of the Queensboro Bridge in 1909, it was possible to take a trolley all the way into Manhattan.

Around the same time, the Long Island Railroad tunnel to Manhattan was completed, making that route even more popular. Then, in 1928, the IRT subway, after years of delay, opened its stop at the intersection of Main Street and Roosevelt Avenue (the old Amity Street), just two blocks north of the Long Island Railroad. The center of downtown Flushing

was now Main Street and Roosevelt Avenue. Jaggar Street had long disappeared, replaced by an extended Main Street.

Sadly, nearly everything old along Main Street is now gone. The lone exception is the 1854 St. George's Episcopal Church. However, continuity might best be represented by the local library. It occupies the same site the old village library occupied at the intersection with Kissena Boulevard. The current, very modern and beautiful building is the fourth library building to occupy the site.

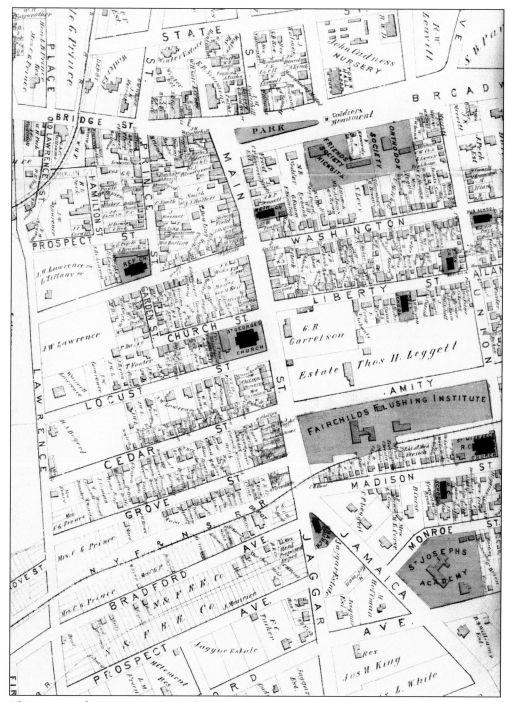

This section of an 1872 map beautifully depicts old Main Street.

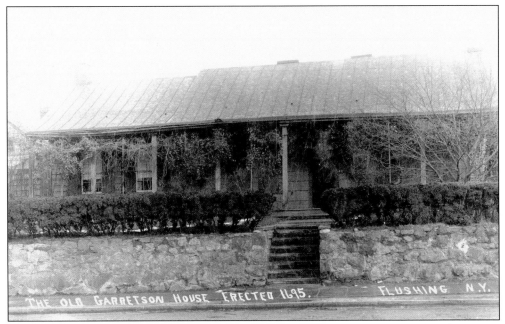

The Bloodgood House was probably the first house built on Main Street. In the mid–19th century, the Garretson family took over the house and started a seed farm on the property. When they required more room, they purchased the land that is now occupied by Queens College.

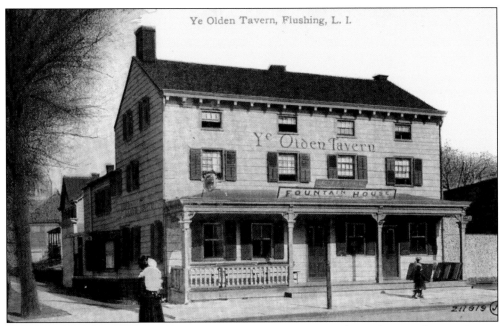

This tavern stood facing Main Street, at the southeast corner of Broadway and Main Street, for nearly two centuries before being torn down in the early 20th century. In its last years, the owners called it Ye Olde Tavern.

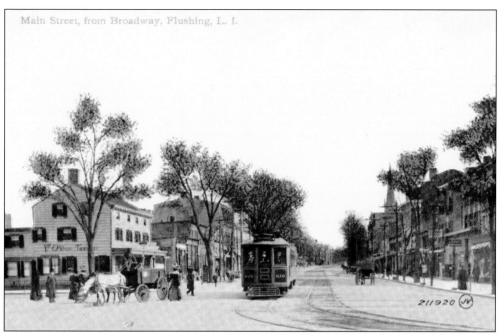

This is a picture of Main Street looking south. The card was probably done around 1900 and shows the trolley traveling south on Main Street. Ye Olde Tavern can be seen to the left, and the steeple of St. George's can be seen in the background to the right.

Main Street. Flushing, L. I,

This different view of Main Street was probably taken around the same time as the previous picture. However, this view is looking north on Main Street toward the Flushing Hotel, the future site of the RKO Keith Theatre.

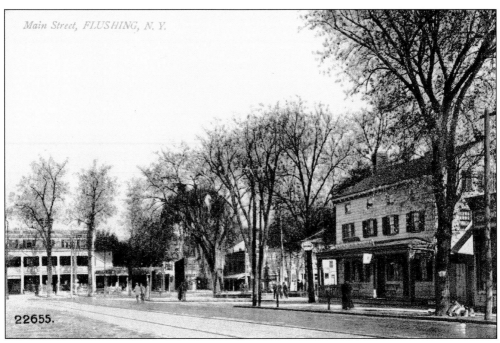

Similar to the previous picture, this is a northeasterly view that shows the old tavern and the fountain at the foot of the Flushing Park.

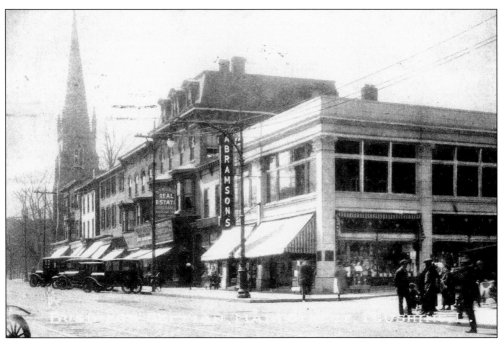

This picture of the northern end of Main Street, about a block south of Northern Boulevard, shows Abramsons Department Store. This photograph appears to have been taken around 1920 before the store expanded into a more modern department store. It survived until the 1950s. St. George's can be seen in the background.

The postcard refers to this as the Morris Building. It was located at the corner of Main Street and Washington Street (now Thirty-ninth Avenue). The first floor was occupied by the *Long Island Times*, a local newspaper. The flags and the photographs of political figures in the window indicate that it was probably taken at election time.

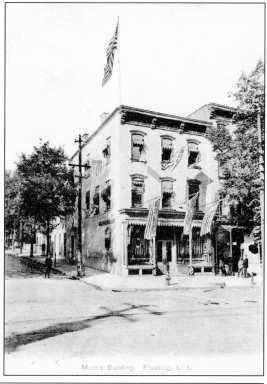

Morris Building. Flushing, L. I.

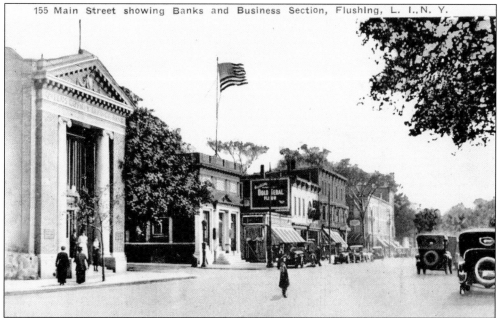

155 Main Street showing Banks and Business Section, Flushing, L. I., N. Y.

By the early 20th century, most of the important banks were located along Main Street. This picture, taken around 1920, shows two of the most important: the Queens County Savings Bank and the Bank of Long Island (the smaller red building), on the opposite side of what is now Thirty-ninth Avenue. Queens County was extensively renovated in the 1950s and was only recently torn down. The other bank disappeared years ago.

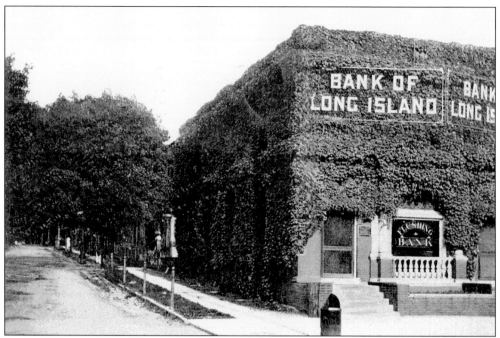

This earlier postcard shows the Bank of Long Island almost completely covered with ivy. This bank was located on the east side of Main Street about one block north of Amity Street, the current Roosevelt Avenue.

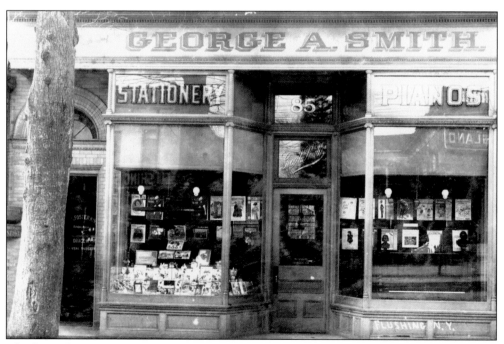

Also located on Main Street in the area of the banks was the George Smith Stationery Store, which also served as the local bookseller. A number of the old postcards of Flushing were published by George Smith.

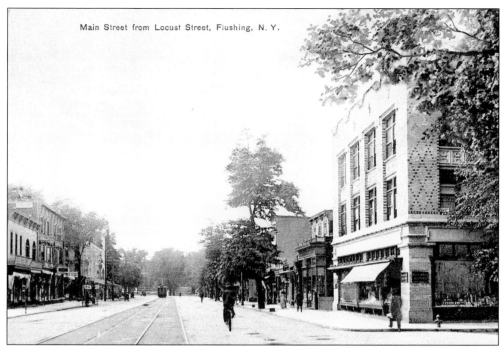

Main Street from Locust Street, Flushing, N. Y.

The building on the right was directly opposite the Bank of Long Island. This building was recently renovated and bears no resemblance to the original. It is just south of St. George's.

On the western side of Main Street, on the block south of Roosevelt Avenue (formerly Amity Street), the Hepburn Pharmacy could be found. Founded in the 1870s as the Hepburn and James Pharmacy, it survived until the late 1950s.

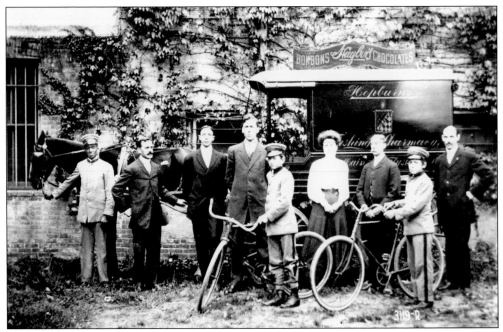

This photograph was taken behind the pharmacy. It dates from around 1900 and appears to be a group photograph of the pharmacy staff. The store was always a family business, so some of the people shown were, no doubt, Hepburns.

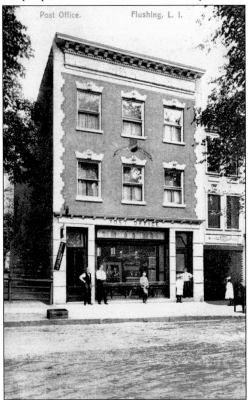

This is a photograph of a post office on Amity Street just east of Main Street. It replaced an earlier one that was the corner building at Main and Amity Streets.

Just as in every small town in America, it was a big day when the circus came to town. This is a postcard advertising one such event.

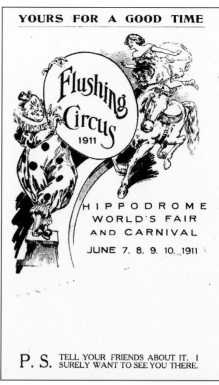

YOURS FOR A GOOD TIME

Flushing Circus 1911

HIPPODROME
WORLD'S FAIR
AND CARNIVAL

JUNE 7, 8, 9, 10, 1911

P. S. TELL YOUR FRIENDS ABOUT IT. I SURELY WANT TO SEE YOU THERE.

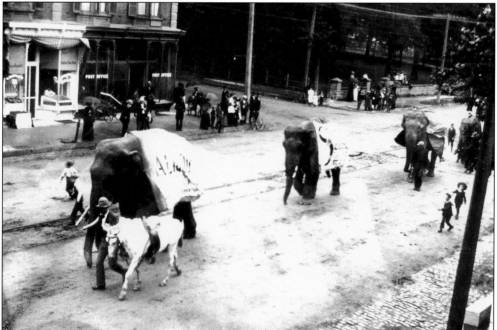

Any parades that took place in the town usually traveled along Main Street. This is a circus parade from 1911. This is the intersection of Main Street and Roosevelt Avenue. The property at the southeast corner is part of the old private school, the Flushing Institute. The circus probably set up its tents on land on the northern side of Broadway.

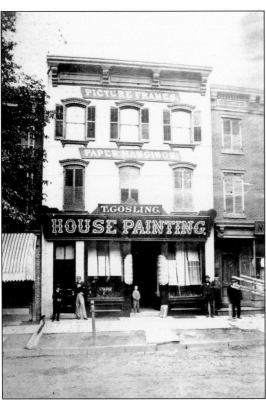

This was T. Gosling's Paint Store, which was located on Main Street south of the Hepburn Pharmacy.

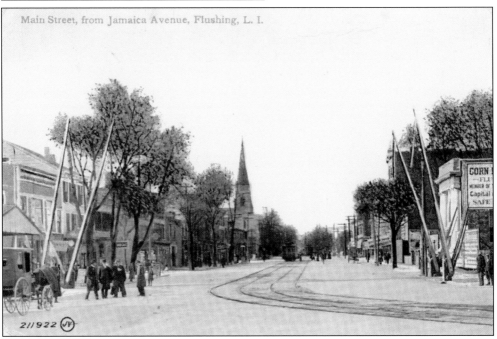

This postcard shows Main Street looking north from where the trolley turned off to travel along Kissena Boulevard on its way to Jamaica. At the time of the photograph, the Long Island Railroad was still at street level, and the guardrails are in an up-position.

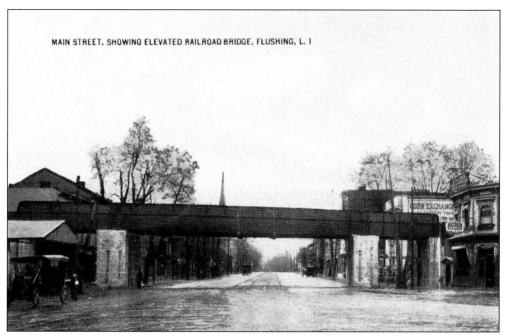

MAIN STREET, SHOWING ELEVATED RAILROAD BRIDGE, FLUSHING, L. I

There were accidents that resulted from the Long Island Railroad traveling along the street. Around 1915, a trestle for the commuter railroad was built over Main Street. This appears to be a picture of the bridge before it was completed.

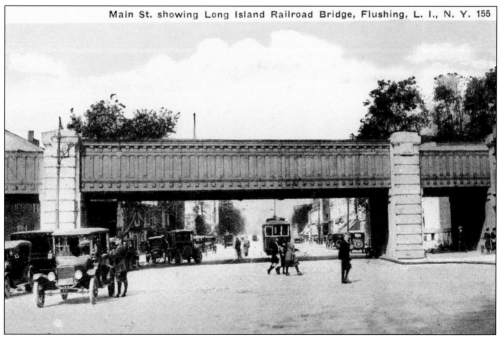

Main St. showing Long Island Railroad Bridge, Flushing, L. I., N. Y. 155

This is the trestle as it looked in the 1920s and it still looks today. The photograph is looking north on Main Street.

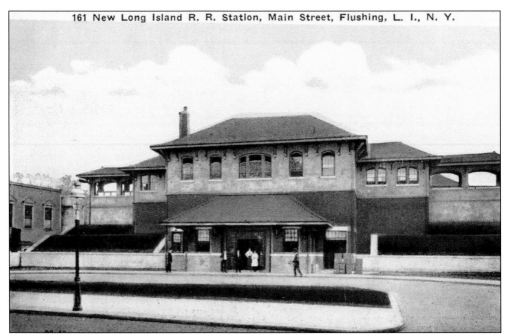

With the building of the trestle, there was a need for a new railroad station to replace the old street level one. Also, with the opening of the tunnel beneath the East River in 1909, there was a dramatic increase in the number of customers, so this attractive, larger station was opened.

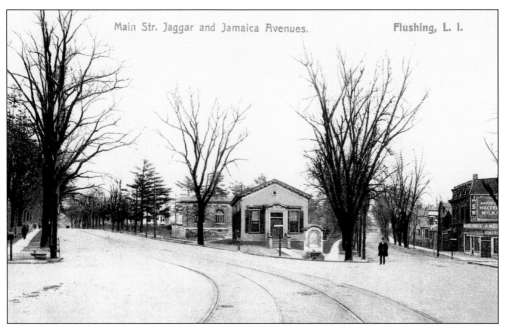

Main Str. Jaggar and Jamaica Avenues. Flushing, L. I.

This postcard shows the view of Main Street looking south. This photograph was taken around 1900; to the right is the narrow Jaggar Street that was a continuation of Main Street. To the left is the much wider Kissena Boulevard (which was still known as Jamaica Road). The small building in the middle is the old village library. In the front of the library is a water fountain used by horses. The fountain can now be found in Flushing Cemetery.

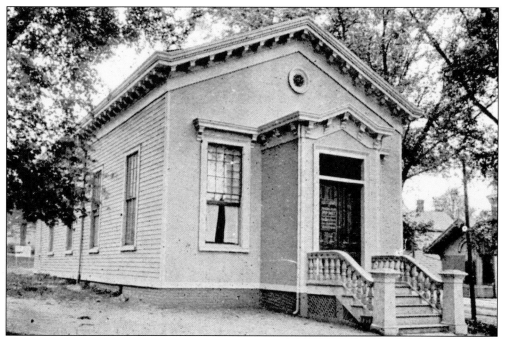

The Free Library of Flushing building was originally the First Baptist Church. When the Baptists opened their new church building in 1890, this was sold to the village and was converted into the village library. Shortly after this photograph was taken, the library became part of the Queens Borough Public Library system.

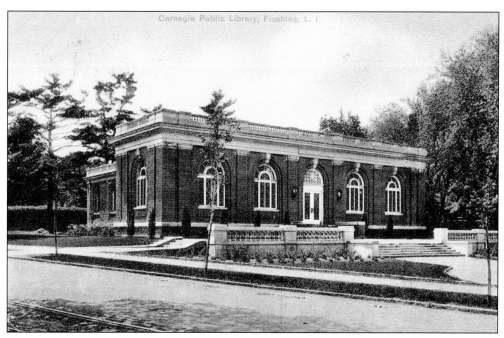

This Carnegie library replaced the old wooden building in 1904. It was one of five libraries in Queens built at that time that was funded by Carnegie money. Sadly, it was torn down in the 1950s when the local library became a regional library and a larger building was needed.

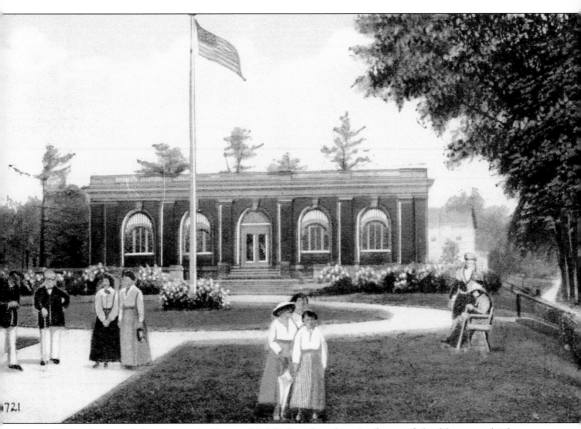

This picture of the Carnegie library highlights the plaza in front of the library, which was a lovely place to stroll and spend a summer afternoon.

Five

CHURCHES AND SCHOOLS

Up until the 1830s, there were only three religious congregations in Flushing: the Quakers, the Episcopalians, and the African Methodists. By the mid-1850s, there were so many new congregations that a local newspaper said that Flushing had become a community of churches. Members of other Protestant sects had moved into the village, as well as an increasing number of Catholics who were mostly Irish.

The Baptists and the Methodists were probably the first to establish new churches, followed closely by the Catholics. The Irish famine of the 1840s increased emigration from Ireland to the United States. Many came to New York City and some moved on to Flushing. Most of the men probably found jobs in the nurseries, and the women became house servants to the middle class and well-to-do. The first Catholic services were held on the second floor of a shop on Main Street. The first actual church was a flimsy building built on Liberty Street, down the block from the African Methodist Episcopal church. In the early 1850s, St. Michael's, a beautiful Gothic-style church somewhat similar to St. George's, was built on Union Street near the Long Island Railroad tracks.

Some of the congregations built newer churches, usually farther south as their congregations expanded and the area nearer to Northern Boulevard became less fashionable. The original Dutch Reformed Church was on Prince Street near Northern Boulevard. In 1892, a new, beautiful church was built on the corner of Bowne Street and Amity Street (now Roosevelt Avenue), then on the outskirts of the village. The Baptists and the Methodists also built newer churches farther south.

The first Jewish congregation was the Temple Gates of Prayer. It was established in 1902 and recently celebrated its centennial. Its original home was on Locust Street, now Thirty-eighth Avenue, across the street from St. George's. In the 1920s, a new synagogue was built on Roosevelt Avenue just east of the Dutch Reformed Church. This was torn down in the 1980s, and another new synagogue was built nearby on Parsons Boulevard. Temple Gates of Prayer is a conservative congregation. In 1915, a reform congregation called the Flushing Free Synagogue was established in an old mansion on Sanford Avenue, near Main Street. In 1930, a beautiful new synagogue was erected around the corner on Kissena Boulevard.

Probably because of its attractiveness and its nearness to New York City, Flushing was the location of a number of private schools in the 19th century. The most famous was the Flushing Institute. This school was housed in a beautiful classical-style building that the Rev. William

Muhlenberg, a former pastor of St. George's, built in 1828. The private schools were generally for the well-to-do. The town did not have public schools until the 1840s, and they were for whites only. The town's black children, if possible, attended the school established by the Flushing Female Society in 1815. It was located on Liberty Street down the block from the African Methodist Episcopal church. Later in the century, the local school district would assume the responsibility for educating the African American children, but the school system would remain segregated until Flushing became part of New York City.

Parochial schools also have an old history in Flushing. The St. Michael's Parochial School was established by the parish in 1853.

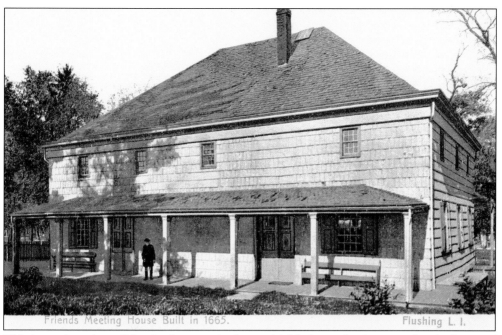

Friends Meeting House Built in 1665. Flushing L. I.

This is another view of the Quaker meetinghouse, highlighting the front porch. The house of worship is both a New York City landmark and is on the National Register of Historic Places.

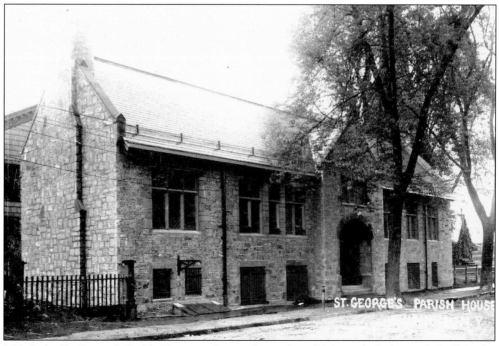

ST. GEORGE'S PARISH HOUSE

This is the St. George's Parish House on Locust Street (now Thirty-ninth Avenue). Built in the early 20th century, it maintains the Gothic style of the church.

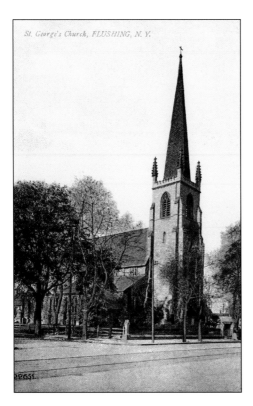

St. George's Church, FLUSHING, N. Y.

This is another view of St. George's Church on Main Street. This is still an active Episcopal church, and today it holds services in Spanish and Chinese as well as English.

St. Michael's Catholic Church was located on Union Street. Built in 1854, it lasted until the 1960s, when it had to be torn down. A new church was built on property a block farther south on Union Street. The original church was built near the Long Island Railroad, and the rumblings of the train probably helped bring about its demise.

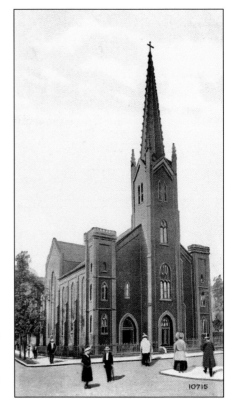

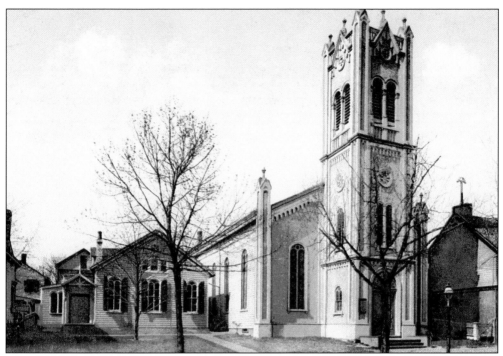

This was the First Methodist Church of Flushing's third church building. The first two were farther north in the village and nearer to Broadway. This church was opened in 1875 and was located on the north side of Amity Street about halfway between Main Street and Union Street. It was torn down around 1950 because the street had become completely commercial. The current church is about half a mile farther east on Thirty-eighth Avenue in quieter Murray Hill.

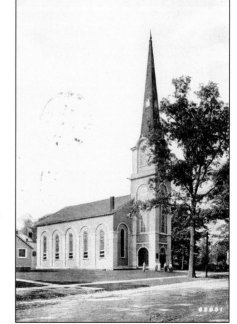

This beautiful New England–style church was the First Congregational Church of Flushing and was built in 1856. It was located on Bowne Street, a short distance north of the First Dutch Reformed Church. A fire destroyed this building in 1970, and the congregation joined with the First Dutch Reformed Church to create the current Bowne Street Community Church.

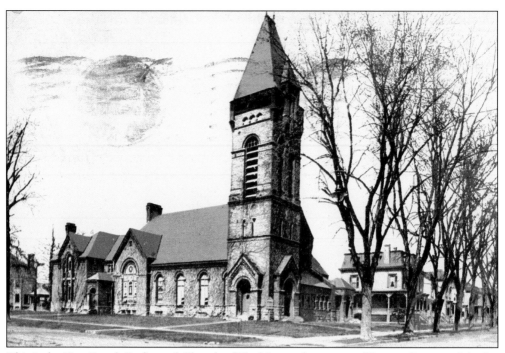

This is the First Dutch Reformed Church of Flushing at the corner of Bowne Street and Amity Street. A beautiful church, it is famous for its stained glass windows. Agnes Northrup, a longtime congregation member, and one of Louis Tiffany's most famous stained glass artists, designed two windows for the church.

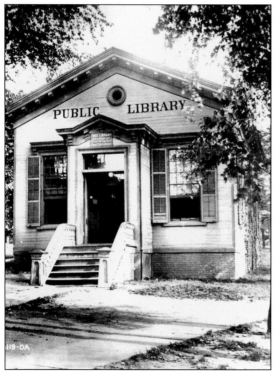

The original First Baptist Church became the town library when the congregation built a new church at the corner of Sanford Street and Union Street in 1890. The congregation had originally moved this building from its old site near Union Street, south of Broadway, around 1870.

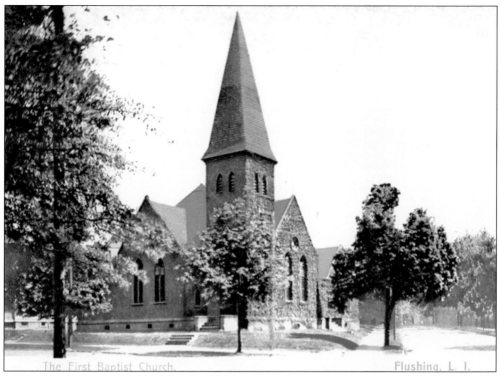

The First Baptist Church. Flushing, L. I.

This is the 1890 First Baptist Church of Flushing at the corner of Sanford Avenue and Union Street. Although it has been altered somewhat, this church is still at its original site. Like most of the original churches of Flushing, its congregation is today mostly Asian.

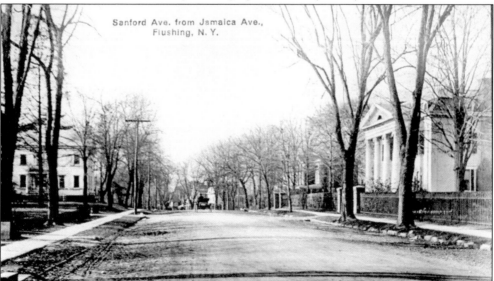

Sanford Ave. from Jamaica Ave.,
Flushing, N. Y.

This *c.* 1900 street scene shows Sanford Avenue looking north from Jamaica Avenue, today's Kissena Boulevard. On the right is the Hoffman Mansion, which became the first home of the Flushing Free Synagogue. Judge Lindley Murray Hoffman built this home in the pre–Civil War era. It is still standing, probably the only surviving pre–Civil War mansion left in downtown Flushing.

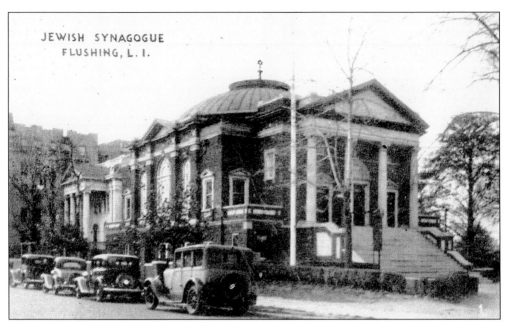

This view of the current Flushing Free Synagogue shows the old Hoffman Mansion in the background. It was built in the late 1920s.

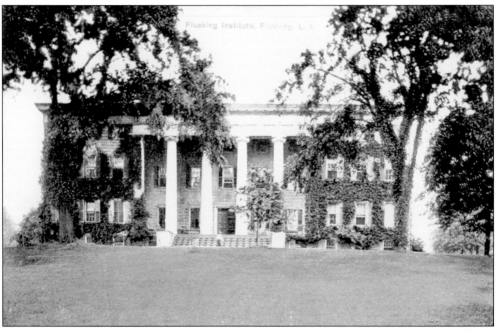

This view shows the Flushing Institute. This school was built in 1828 by the Rev. William Muhlenberg. He moved his school to College Point in the mid-1830s and expanded it into a college he called St. Paul's. After a number of private schools occupied the building, Elias Fairchild moved his school into the building in 1845. His school, also called the Flushing Institute, survived until the early 20th century. It was a well-known prep school in its day, even attracting students from some Latin American nations.

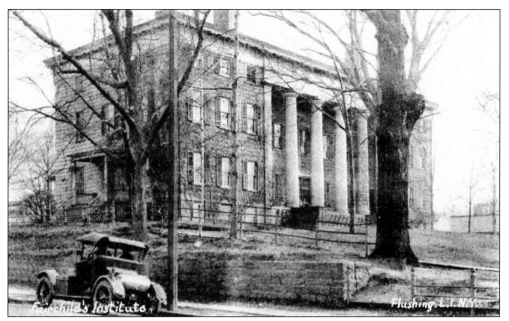

This later view of the Flushing Institute appears to have been taken around 1920, years after the school went out of business. The building appears to still be in good shape. It was torn down in the early 1920s. The school was sometimes called Fairchild's Institute, which explains the caption on the card.

Another well-known private school was the Kyle Institute. This was a military academy and was located north of Broadway. The school was most popular in the early part of the 20th century, years after the Flushing Institute went out of business.

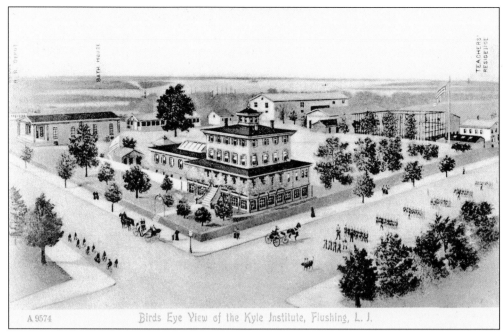

This is a bird's–eye view of the Kyle Institute. It shows the entire campus. It even shows the students marching on Thirty-fifth Avenue. As with many private schools in Flushing, the school took over one of the great mansions from an earlier era.

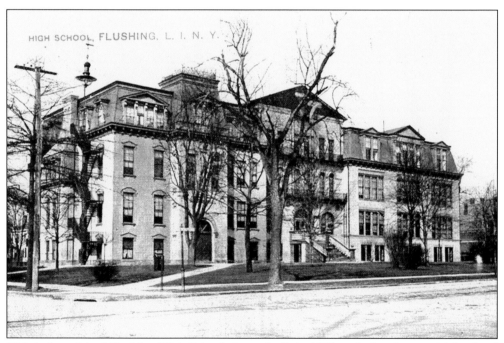

This is the original Flushing High School. It was built in 1875, and after the new high school was built, it was used to house an elementary school. It was the first high school in New York City to be chartered by the state.

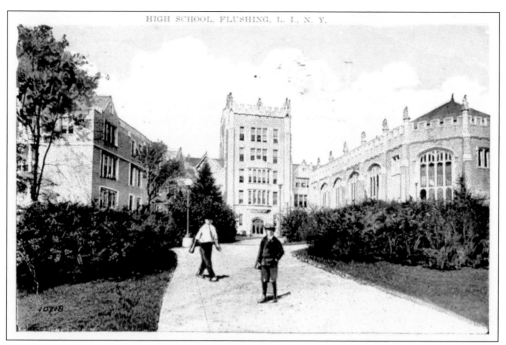

This is another view of the "new" Flushing High School on Northern Boulevard. This beautiful school building was declared a New York City landmark in 1991.

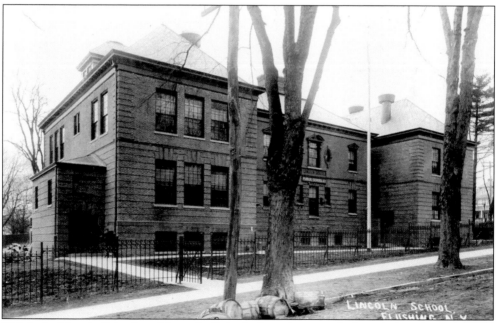

This is the Lincoln School, and it was built in the late 1890s, just before Flushing became a part of New York City. The village built four schools at the time: Lincoln, Washington, Jackson, and Jefferson. This is the only one still standing, and it is one of the few pre-consolidation school buildings still in use in Queens.

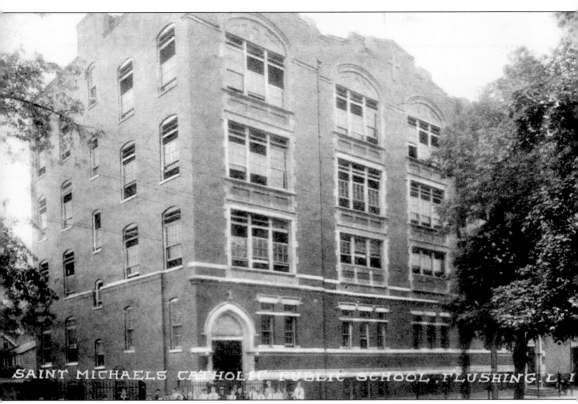

Catholic parochial schools have an old history in Flushing. The first built was St. Michael's, which was opened in 1852. The postcard shows St. Michael's second school building, which opened in 1914.

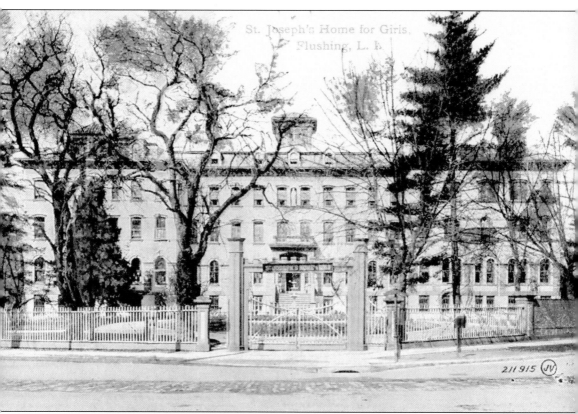

St. Joseph's Home for Girls,
Flushing, L. I.

This building stood at the corner of Kissena Boulevard and Sanford Avenue and was used for various purposes by the Catholic Church. Initially, it was an exclusive school for Catholic girls, later it was used as an orphanage, and lastly as a convent for retired nuns. It was destroyed by fire in the early 1960s and was replaced by a Korvette's department store, which is now also gone.

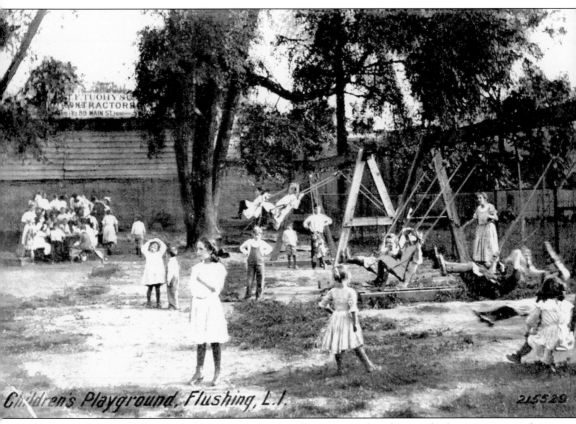

Children's Playground, Flushing, L.I.

215529

The playground shown in this picture was actually connected with an early day-care center that was established by a volunteer group in Flushing to assist working women in the community in the early 20th century. It was located on what is today Barclay Street.

Six

MURRAY HILL

As transportation improved, Flushing kept growing. By 1900, new real-estate developments on the outskirts of the old village started appearing. One of the first was Murray Hill, which was developed south of Broadway to the east of the village. By 1889, Frederick Dunton, a well-known Queens developer, had purchased a large portion of the Robert Bowne Parsons Estate, which was just east of the Parsons nursery. Dunton was the nephew of the president of the Long Island Railroad and was on its board of directors. He was probably instrumental in getting the railroad to build a new station right in the middle of the property. Murray Hill became an early railroad suburb, a community that grew up around a railroad station, one of the many on Long Island. This new stop on what would become the Port Washington line of the Long Island Railroad was the first one east of the Main Street stop, less than a mile away. The name comes from the Murray family, an old Flushing family that owned the land to the east of Murray Hill.

The land was divided into lots, and the first auctions were held around the time the railroad station, a beautiful, long-gone Victorian building, was opened to the public. Sales appeared to go slowly at first, but they picked up, and the opening of the Long Island Railroad tunnel under the East River in 1909 made Murray Hill a particularly attractive place to live. After 1909, a train could reach midtown Manhattan from the Murray Hill station in under a half hour. Many of the homes built in Murray Hill, particularly the ones on Sanford Avenue, were beautiful and quite large; however, most were more modest middle-class homes. The first church built in Murray Hill was St. John's, which started as a chapel of the St. George's Episcopal Church on Main Street before becoming an independent congregation.

Murray Hill never became a separate village but was always considered politically a part of Flushing. It did develop its own identity. For example, it had its own shopping center around the railroad station, and even though the school and firehouse were part of the Flushing districts, they were identified as the Murray Hill School and Murray Hill Firehouse. Murray Hill would continue to undergo changes, and, as early as the 1920s, small apartment buildings started appearing. Gradually, Murray Hill went from being a suburban community to a more urban one. Many of the old homes, not the grand ones but the more modest ones, still stand today. A few beautiful homes on Sanford Avenue have survived, but one is a Korean church and another a nursery school.

One of the surviving homes is now the Voelker Orth Museum. It was originally built around 1891 and was purchased in 1899 by Conrad Voelker, a publisher of German American newspapers.

Voelker died in 1930 and his daughter, Theresa, and her husband, Dr. Rudolph Orth, lived in the house for many years. Their daughter, Elisabetha Orth, lived there all her life. In her will, she left funds to establish the home as a museum. It has been fully restored and is now open to the public.

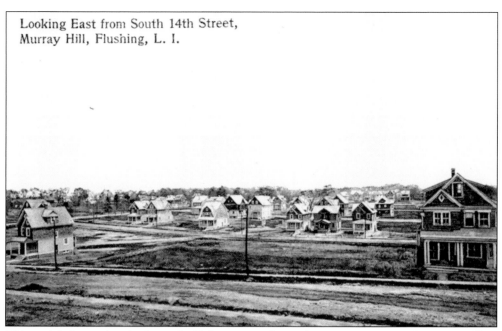

Looking East from South 14th Street,
Murray Hill, Flushing, L. I.

This aerial view, taken in the early 20th century, shows the eastern portion of Murray Hill. It appears that at this point much of it is still vacant land.

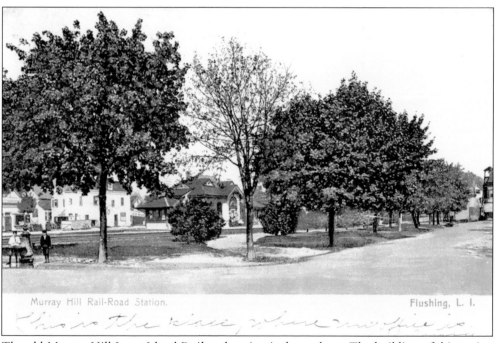

Murray Hill Rail-Road Station. Flushing, L. I.

The old Murray Hill Long Island Railroad station is shown here. The building of this station made the development of Murray Hill possible. Notice the large plaza around the station. The station itself is in the middle. At this time, the trains were running along street level. A cut was dug around 1915, and the trains now run below the street level. Today the plaza is gone, there are just platforms alongside the tracks, and there is no longer a station building.

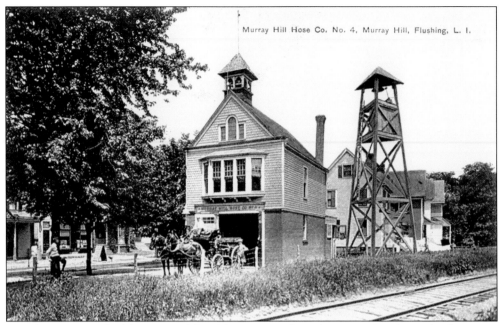

Murray Hill Hose Co. No. 4, Murray Hill, Flushing, L. I.

Seen here is a wonderful picture of the old Murray Hill Firehouse. It also shows the fire tower next to it.

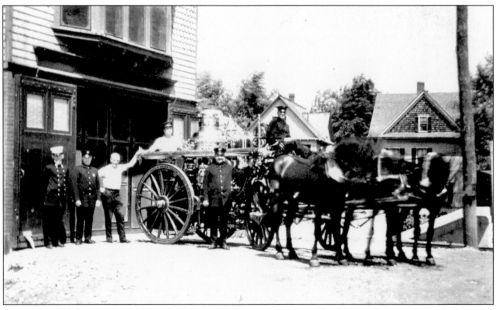

This view of the firehouse shows volunteer firemen getting the horse-drawn fire truck ready. Although Flushing became legally part of New York City in 1898, the city fire department did not take over from the local volunteer companies until 1908.

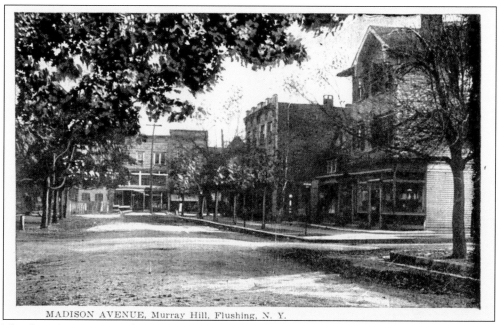

MADISON AVENUE, Murray Hill, Flushing, N. Y.

The shopping center in old Murray Hill is seen here. Madison Avenue is today called Forty-first Avenue. On the left is the plaza for the Long Island Railroad station.

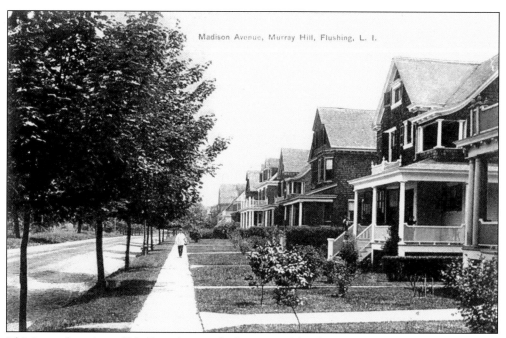

Madison Avenue, Murray Hill, Flushing, L. I.

This is another view of Madison Avenue farther west of the shopping center. These were typical Murray Hill homes that were probably erected around 1910.

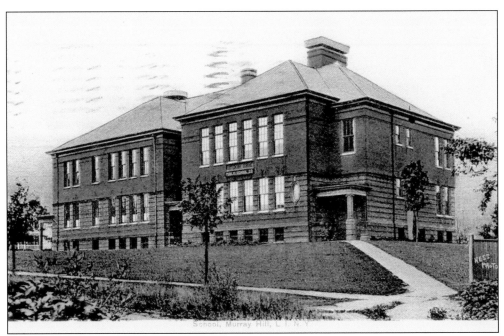

The Murray Hill School was opened in 1897. It was one of the four schools that the village built in the late 1890s. This building was much larger than needed at the time. It was officially known as the Thomas Jefferson School or PS 22. It was more commonly known, at least in its early years, as the Murray Hill School. This building survived until the 1970s, when it was torn down and a new PS 22 was erected next door.

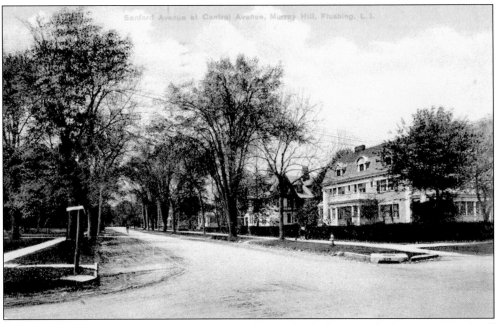

Some of the most beautiful homes in Murray Hill were built along Sanford Avenue. Nearly all are gone today.

The landscaping along Sanford Avenue and many of the other streets in Murray Hill was quite attractive. The developers advertised that mature-growth trees were planted along some of its streets.

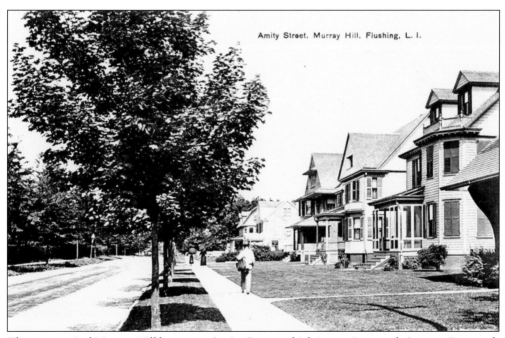

These are typical Murray Hill houses on Amity Street, which is now Roosevelt Avenue. Roosevelt Avenue runs into Northern Boulevard at the eastern end of Murray Hill.

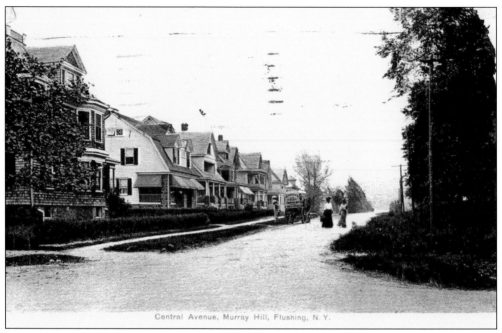

Central Avenue, Murray Hill, Flushing, N. Y.

Pictured here are some more typical homes on Central Avenue. This shows the roads were not yet paved and that one side of the street was built-up but apparently the other side was not. Central Avenue is now 149th Street.

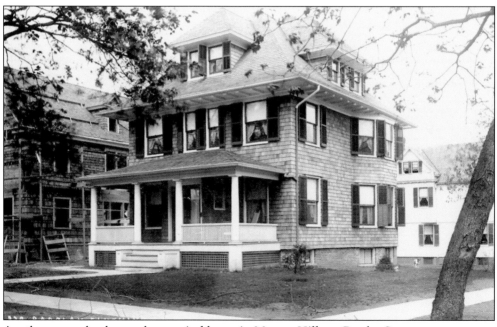

Another somewhat larger-than-typical home in Murray Hill, on Barclay Street.

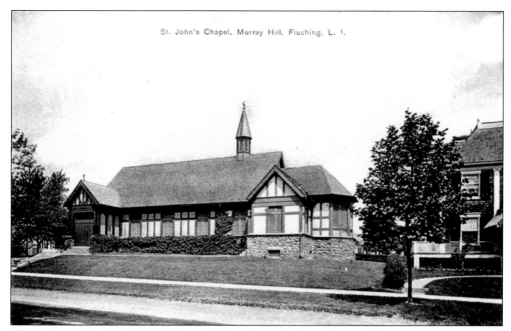

This is the original St. John's Episcopal Church on Sanford Avenue. The congregation started as a chapel of St. George's Episcopal Church on Main Street and later became an independent congregation. This Tudor-style church was destroyed by fire, and a Gothic-style building took its place in 1920.

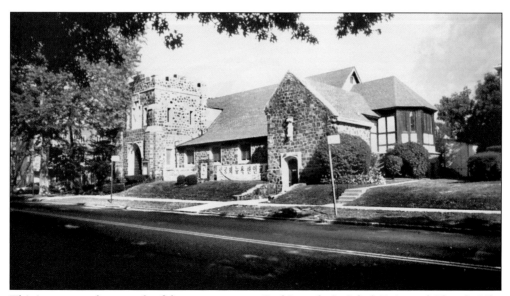

This is a recent photograph of the current, more Gothic-style St. John's Episcopal Church. Like many of the old churches of Flushing, the old congregation shares the building with a new Asian congregation.

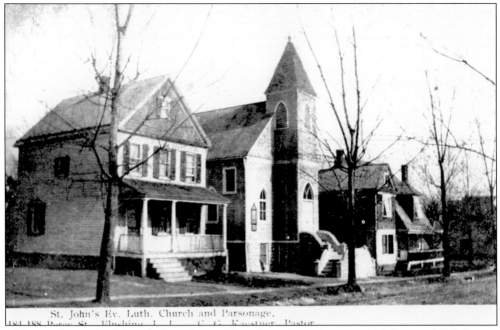

St. John's Ev. Luth. Church and Parsonage,
184-188 Percy St. Flushing, L. I. C. G. Kerstner, Pastor.

This was the original St. John's Lutheran Church on Percy Street, which is now 147th Street. It was opened in the 1890s. In the 1950s, the Lutherans moved to a new building on Sanford Avenue, and a Greek Orthodox congregation took over this building. Today it is a Russian Orthodox Church.

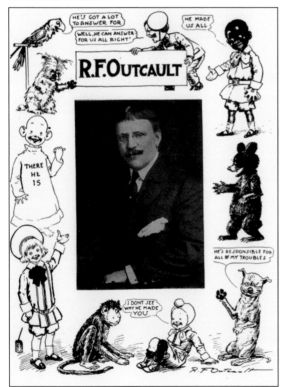

The most famous resident of Murray Hill was probably Richard Outcault, the well-known cartoonist. His first success was *Hogan's Alley*, which included a character named the Yellow Kid from which the term yellow journalism was coined. His later comic strip was the famous *Buster Brown*.

Richard Outcault lived on Percy Street for many years. He drew this cartoon for a businessman's association pamphlet boosting Flushing as a place to live and do business.

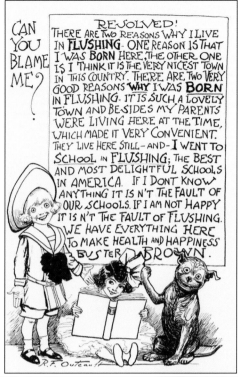

CAN YOU BLAME ME?

RESOLVED! THERE ARE TWO REASONS WHY I LIVE IN FLUSHING. ONE REASON IS THAT I WAS BORN HERE, THE OTHER ONE IS I THINK IT IS THE VERY NICEST TOWN IN THIS COUNTRY. THERE ARE TWO VERY GOOD REASONS WHY I WAS BORN IN FLUSHING. IT IS SUCH A LOVELY TOWN AND BESIDES MY PARENTS WERE LIVING HERE AT THE TIME, WHICH MADE IT VERY CONVENIENT. THEY LIVE HERE STILL - AND - I WENT TO SCHOOL IN FLUSHING; THE BEST AND MOST DELIGHTFUL SCHOOLS IN AMERICA. IF I DONT KNOW ANYTHING IT IS N'T THE FAULT OF OUR SCHOOLS. IF I AM NOT HAPPY IT IS N'T THE FAULT OF FLUSHING. WE HAVE EVERYTHING HERE TO MAKE HEALTH AND HAPPINESS BUSTER BROWN.

R.F. Outcault

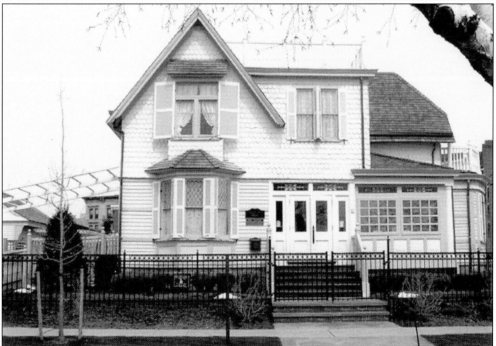

This is the newly restored Voelker Orth House. Conrad Voelker purchased this house in 1899 and started modifying it. The house was recently restored to the way it looked in 1909, the year Voelker finished his alterations.

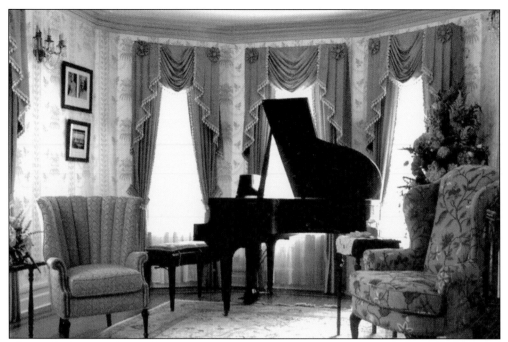

This is the front parlor in the recently restored Voelker Orth House. The piano, which was purchased by Voelker's son-in-law, Dr. Rudolph Orth, in 1930, is a Sohmer and Company piano made at the company's plant in Astoria, Queens.

This is the garden of the Voelker Orth Museum. Elisabetha Orth, the last of the family members to live in the house, was an avid gardener, and one of the museum's goals is to recreate a Victorian garden.

Seven

OTHER DEVELOPMENTS
IN THE BROADWAY AREA

Broadway-Flushing is the name of the community just east of Murray Hill along Broadway, today's Northern Boulevard. The name, which was first used in the early 20th century, is derived from the Broadway stop on the Long Island Railroad, which is the next stop east of Murray Hill. At the Broadway station, the Long Island Railroad crosses Broadway, leaving Flushing behind, and travels toward Bayside, Little Neck, and other points east. As in the case of Murray Hill, although somewhat later, real-estate developers started buying up the estates and building upscale suburban homes.

The chief developer of the Broadway area was the Rickert-Finley Company, the most important real-estate developer of the north shore area of Queens. By 1910, the firm started buying land north of Broadway and near the station. Around 1915, the Long Island Railroad, as part of a safety program, started raising the street level tracks and putting them on an embankment or in some areas putting them below ground by digging a cut. This created a need for a trestle over Broadway and a new station to replace the old street level one. Most of the Rickert-Finley homes are still standing today and the area remains a beautiful residential community.

In addition to Broadway, other areas near Broadway were developed around the beginning of the 20th century. One of the earliest developments was Bowne Park. This was built on land that used to be part of the Walter Bowne estate. Walter Bowne, a direct descendant of John Bowne, was a mayor of New York City in the 1830s. At the heart of the development was an actual park with a beautiful lake at its center. This eventually did become a New York City park. As early as the mid-1890s, developers started constructing the first homes in the development. Most of the early homes are now gone.

Another upscale area of Flushing was Bayside Avenue, which is really at the very northern edge of the old village area. After 1910, a number of beautiful homes were built in the area. Many of them are still standing, but their large lots make them attractive to developers. The most famous individual who lived along Bayside Avenue was Richard Hellman, the founder of the Hellman's Mayonnaise Company.

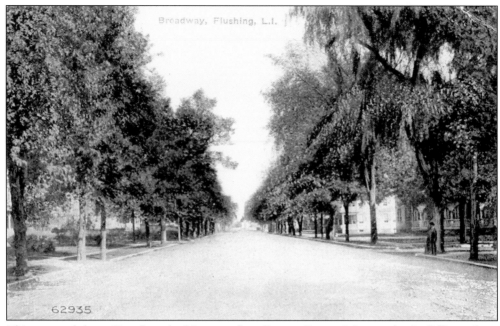

This postcard shows Broadway looking east from Bowne Street. It is completely different from a westerly view, which would show a part of downtown Flushing.

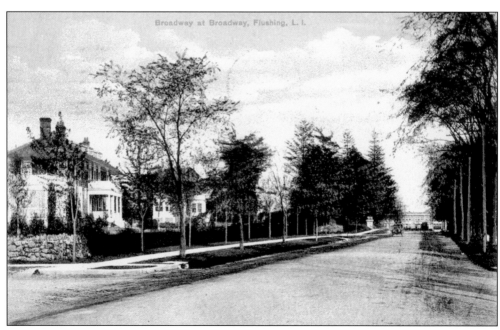

This is another early view of Broadway looking east. This one is closer to the Long Island Railroad station. The Rickert-Finley Building can be seen in the background.

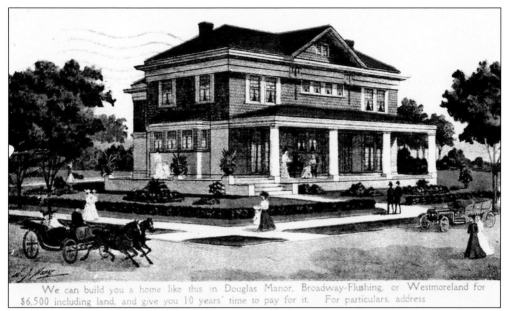

We can build you a home like this in Douglas Manor, Broadway-Flushing, or Westmoreland for $6,500 including land, and give you 10 years' time to pay for it. For particulars, address

This postcard was a Rickert-Finley advertisement. They would not only sell the lot but would also build a beautiful home like the one in the picture. Some of the older homes in the communities mentioned resemble the one in the advertisement.

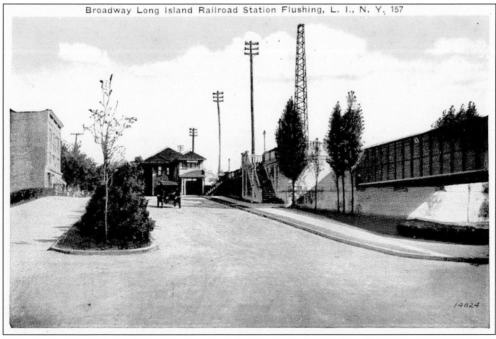

Broadway Long Island Railroad Station Flushing, L. I., N. Y. 157

This is the "new" Long Island Railroad station that was built after the trestle was completed around 1915. The street adjoining the station is called Station Road.

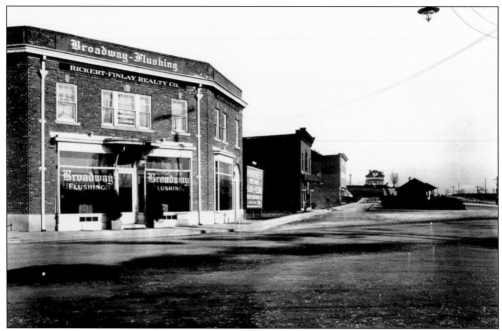

Pictured is the Rickert-Finley Building across the street from the Long Island Railroad station. Rickert-Finley was the major real-estate developer along the north shore of Queens. Their deeds contain strict building restrictions governing what could be built on the lots. This helps explain why much of the Broadway-Flushing area has survived intact and many other early 20th century real-estate developments have not.

These are stores on Station Road across the street from the Broadway station.

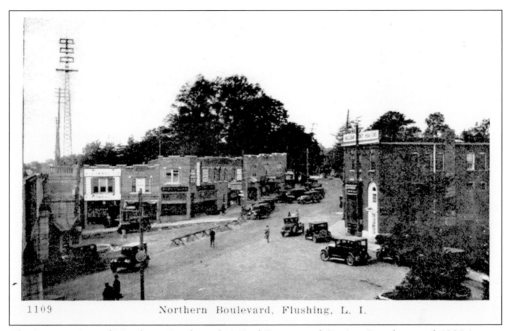

1109 Northern Boulevard, Flushing, L. I.

The intersection of Northern Boulevard, 162nd Street, and Station Road around 1925 is seen here. The Rickert-Finley Building is on the right.

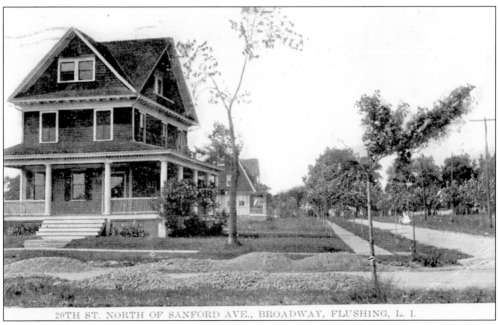

20TH ST. NORTH OF SANFORD AVE., BROADWAY, FLUSHING, L. I.

Part of the Broadway community was south of Northern Boulevard. This home was near 160th Street and Sanford Avenue. Most of the homes in this area were not as expensive as the ones north of Broadway.

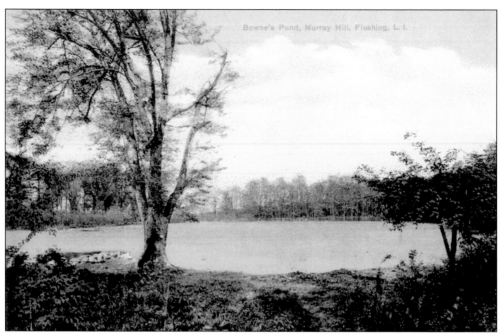

This is a postcard showing Bowne Pond. Formerly part of the Walter Bowne estate, the ponds and the springs in the area were at one time a backup part of the village's water supply system.

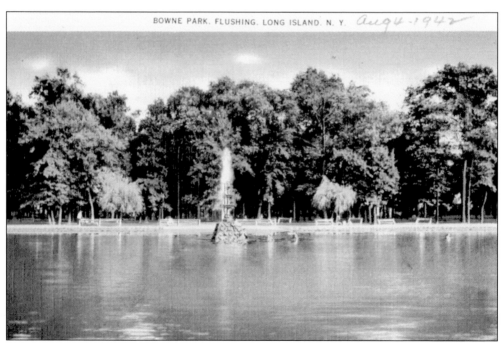

This is Bowne Pond after it became part of Bowne Park, a city park. The park is between 158th Street and 160th Street, between Thirty-second Avenue and Bayside Avenue. Notice the fountain in the middle of the lake and the other changes that have been made to the pond.

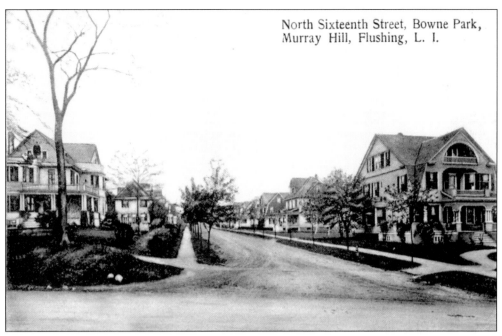

North Sixteenth Street, Bowne Park,
Murray Hill, Flushing, L. I.

North Sixteenth Street is today's 155th Street. These homes were a couple of blocks north of Broadway. Some of the old postcards say that Bowne Park was a part of Murray Hill. This is possibly because many of the residents used the Murray Hill station.

Here are more Bowne Park homes. According to the information on the back of the card, these were bought at foreclosure and could be had at a bargain price of $8,000. Notice how small the lots were, which could explain why they did not sell. Much of the real-estate development ended in failure.

91

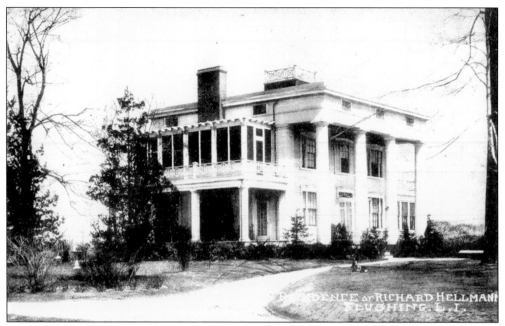

This mansion was built on Bayside Avenue near 149th Street. It was the home of Richard Hellman, the "mayonnaise king." It was torn down in the 1950s and replaced by a garden apartment complex. Hellman invented his famous mayonnaise while he ran a deli in Manhattan. Later he built a factory in Long Island City and built this beautiful home in Flushing around 1915.

This is another Bayside Avenue home farther west. A number of larger homes in the area became boardinghouses during the 1939 World's Fair. A number of beautiful homes on Bayside Avenue have survived, although the size of their lots makes them an inviting target for real-estate developers.

Eight

THE WALDHEIM AREA

Waldheim is a German word meaning "a house in the woods," and it was the name real-estate developers gave to an exclusive development that was constructed in Flushing in the first decade of the 20th century. The lots were quite expensive for their time and each of the owners, some of whom were well-to-do Manhattan businessmen, had homes constructed that were very different from each other, but somehow they all blended together to make a very attractive neighborhood. It was a small development, extending from Ash Street, to Beech Street, to Cherry Street, between Parsons Avenue and Bowne Avenue. In keeping with the bucolic name, the streets were not a typical grid pattern but meandered somewhat, and they were beautifully landscaped. This was another early suburban development in the Flushing area made possible by the improvements in transportation. The trolley traveled along Bowne Avenue, and it was only a short ride or a nice walk to the Main Street Long Island Railroad station.

The developers built Waldheim on land that had originally belonged to Sanford Hall. This early sanatorium for the mentally ill was founded in 1844 by Dr. James MacDonald, a well-known early psychiatrist. The main building had originally been a mansion built in 1836 by Nathan Sanford, a senator from New York and a onetime vice-presidential candidate, who lived in Flushing for many years before his death in 1838. The institution was ahead of its time in its humane treatment of the mentally ill. Although the hospital, which was run by the MacDonald family after the death of the founder, sold much of the original hospital grounds, it managed to survive until the 1920s, when the Sanford mansion was torn down by real-estate developers.

Another nearby medical institution, Flushing Hospital, was already in existence when Waldheim was begun. It is only a block or two south of the development on the west side of Parsons Boulevard. The hospital land had originally belonged to John Henderson, another well-known Flushing nurseryman and florist, who provided Manhattan flower shops with many of their cut roses. It is believed that the hospital, the first in Queens, came about because the maid of one of the village's wealthy women took ill. They rushed her to the nearest hospital, which was in Brooklyn, but the journey took too long and she died. The well-to-do women of the village decided to raise money for the purpose of opening a hospital. One of the interesting things about the hospital is that in its early years it was run by a board of women managers. The first building was erected in 1887, but around the time that Waldheim was being built, the hospital managers erected its first brick building. In 1910, they replaced the earlier brick building with a very modern hospital building for its day. It is still a part of today's Flushing Hospital complex.

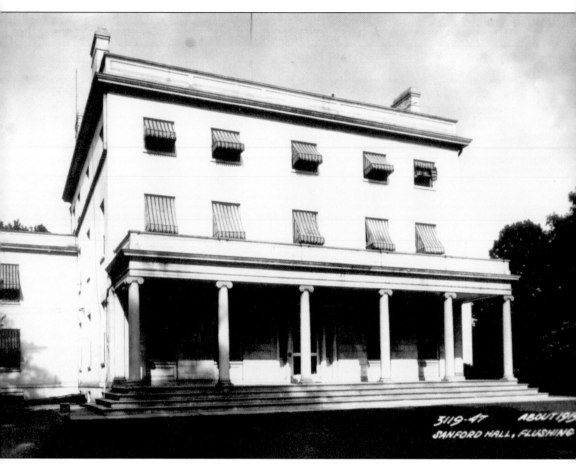

This mansion was originally built by Sen. Nathan Sanford in 1836. In 1844, it was purchased by Dr. James MacDonald, who used it to house a highly regarded institution for the mentally ill. In the early 20th century, part of the land was sold for the Waldheim development.

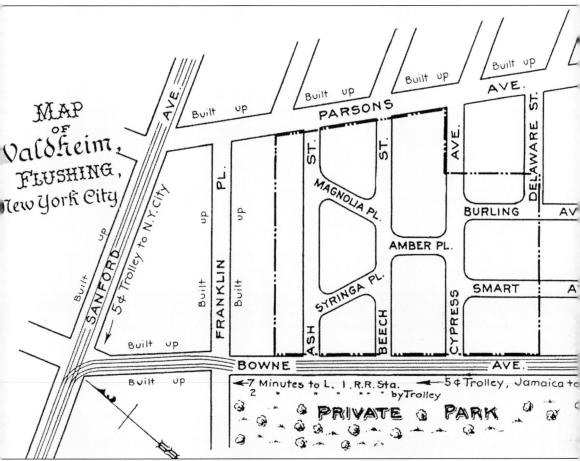

A map from a real-estate agency shows the outlines of the Waldheim development. It also shows how accessible the new development is. The "park" is actually the remaining land of the Sanford Hall asylum. The developers did not want to advertise that a new home owner would be living next door to what many called an insane asylum.

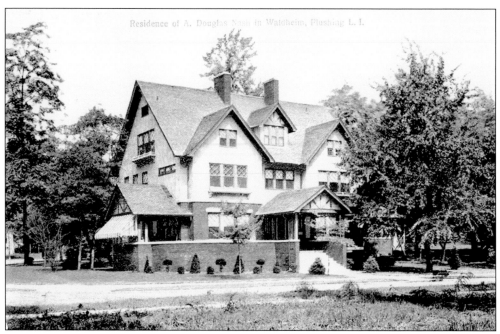

This is a picture of what was the largest house in Waldheim. This was the home of A. Douglas Nash. Nash was an English glassmaker who Louis Tiffany brought to America and put in charge of his glass factory, which was located in nearby Corona. Although many of the Waldheim homes still survive, this house was torn down in the 1980s.

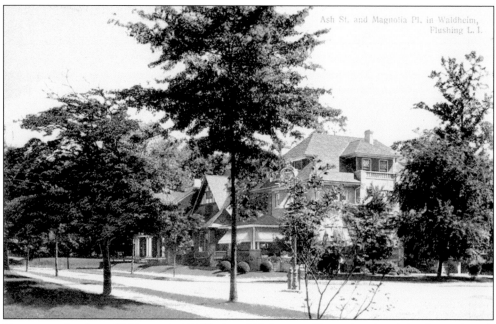

Here is another beautiful home in Waldheim. This home still survives, but it has been altered, as have a number of the homes from the early development. The early picture gives a good view of the landscaping.

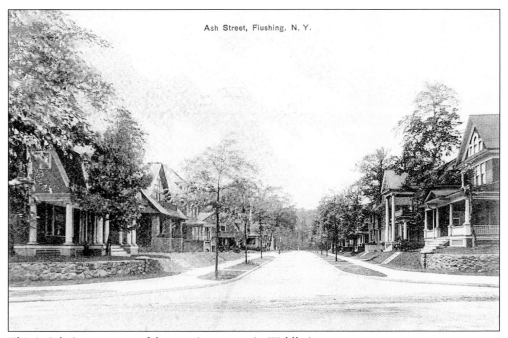

This is Ash Avenue, one of the prettiest streets in Waldheim.

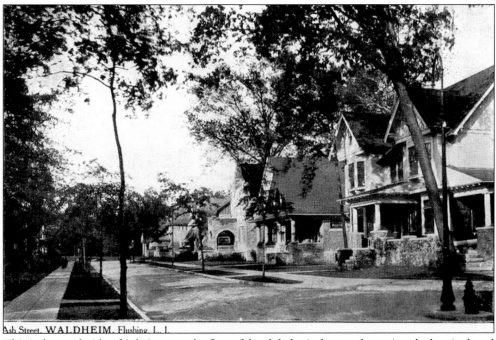

This is the south side of Ash Avenue, the first of the alphabetical streets honoring the horticultural heritage of Flushing.

This is the north side of Ash Avenue. A number of these homes have survived, but attempts to have the district declared a landmark district have so far failed, and the old homes in Waldheim are disappearing.

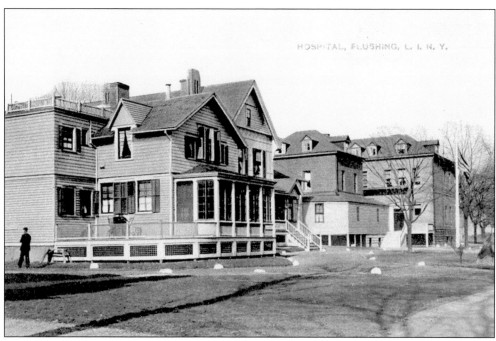

HOSPITAL, FLUSHING, L. I. N. Y.

Flushing Hospital was actually started in 1883. The first buildings were the wooden buildings shown in this picture. Forest Avenue is now Forty-fifth Avenue.

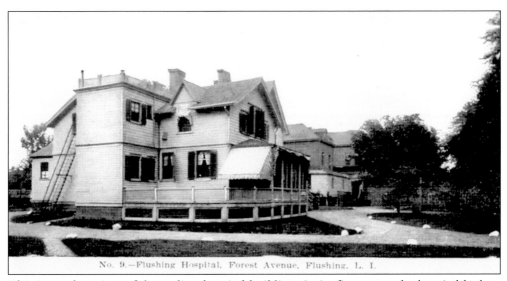

No. 9.—Flushing Hospital, Forest Avenue, Flushing, L. I.

This is another view of the earliest hospital building. In its first years, the hospital had no permanent home but consisted of the female board of managers who would actually visit the sick and assign nurses to help them in their homes. The very ill were sent to hospitals in Manhattan. They erected this first building in 1887.

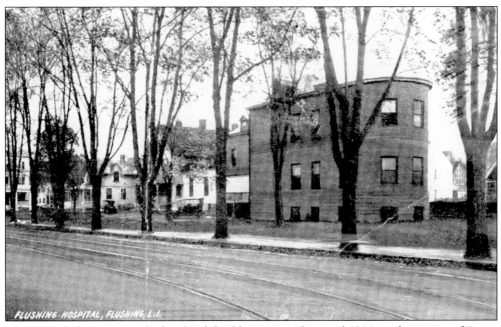

This was Flushing Hospital's first brick building, erected around 1900, at the corner of Forest Avenue and Parsons Boulevard.

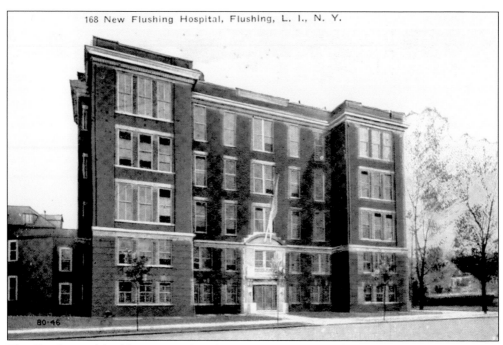

168 New Flushing Hospital, Flushing, L. I., N. Y.

The first hospital buildings proved inadequate, so this state-of-the-art building was erected in 1910.

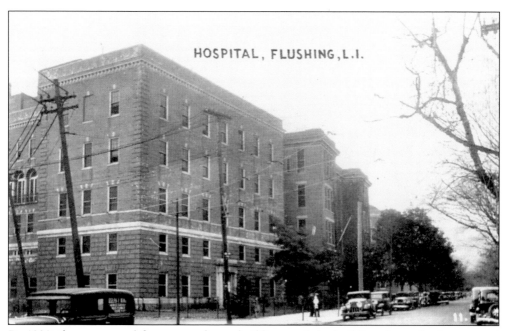

HOSPITAL, FLUSHING, L.I.

By 1930, there was need for an even larger building, and the building shown in the postcard above was erected. The 1910 building can still be seen next door, and next to that was the nursing school. The old hospital was becoming a medical center.

Nine

KISSENA PARK AREA

In the early 1870s, Robert Bowne and Samuel Bowne Parsons decided to divide the family nursery business. Robert kept the original nursery along Broadway while Samuel established a new nursery near Kissena Lake, about a mile south of the old nursery. A road was completed by the two brothers to connect their nurseries. The street, that is today called Parsons Boulevard, actually travels from Northern Boulevard (today's name for Broadway) to Kissena Park where the old portion of the road ends. It is not clear who named the lake Kissena, a Native American word for cool water, but it was named shortly before Parsons set up his business and has nothing to do with local Long Island Native Americans. In part, Parsons chose this new site for the nursery because it was near a station for the Flushing Central Railroad, which went out of business a few years after he opened the Kissena nursery.

Samuel Bowne Parsons died in 1906, and his family sold off the Kissena nursery a few years later. Some of the land was sold to New York City, and it was combined with other parcels of land to create Kissena Lake Park, which is today called Kissena Park. However, most of the land was sold to the real-estate firm of Paris and MacDougal. They started a development that bordered the park, which they also called Kissena Park. In the beginning, as with other developments in the area, it consisted of mostly large-scale suburban homes. Later more modest middle-class homes were built. The most impressive home was actually built for John Paris, one of the developers. It faced the park on the opposite side of Rose Avenue, the last in the series of alphabetical streets named for trees and plants.

Kissena Park opened to the public in 1910. On the left, when entering the park from the Parsons Boulevard entrance, there are rows of trees that are the remnants of the old Parsons nursery from a hundred years ago or more. This is the only surviving section of the historic nurseries. In the early years, the park had a more Victorian look with beautiful stone bridges, gazebos, boathouses, and so forth. Later, in the 1930s and the 1940s, much of the early design was done away with, and there was more of an emphasis put on concrete. The centerpiece of the park, the beautiful Kissena Lake, originally had a natural shoreline, but it was later encased in concrete. Despite all these changes, it is still a beautiful park that serves the community well.

Diagonally across from the southeast corner of the park is Flushing Cemetery. This is more than 50 years older than the park. The nondenominational cemetery opened its doors in 1853 and was the result of a passage of a state law that encouraged communities to establish

cemeteries outside the populated central village areas. Nearly all the cemetery lies just outside the old village boundary line. The Flushing Cemetery Corporation was established, which is still in existence and runs the cemetery today. Robert Bowne Parsons, the nurseryman, was its first superintendent, and since the beginning, someone in the nursery business or a landscape architect has always served on its board of directors. Many people visit in the fall or spring just to appreciate the beautiful trees and flowers.

The Parsons Historic Tree Grove in Kissena Park is just inside the park's entrance.

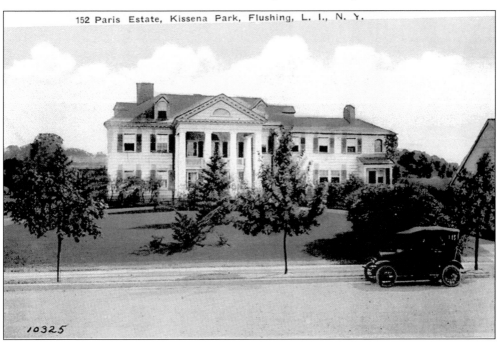

152 Paris Estate, Kissena Park, Flushing, L. I., N. Y.

10325

Although it looks much older, this home was completed around 1910 for real-estate developer John Paris. It was across the street from the Parsons Boulevard entrance to Kissena Park. It was the centerpiece of his new development, Kissena Park. None of the other homes he built were quite so large. Frances Paris, his wife, started the local Garden Club, and her own garden on the property was famous for its beauty. The house was torn down in the late 1950s.

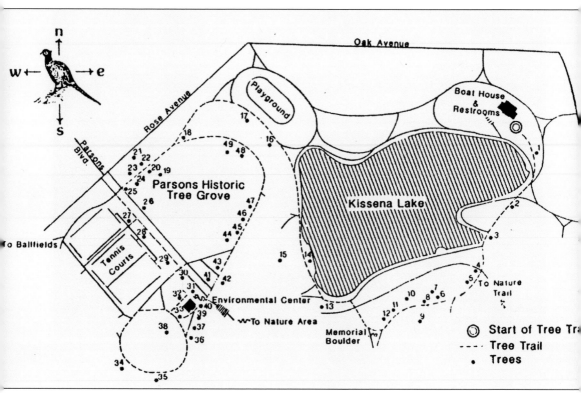

This is a picture showing a portion of Parsons Historic Tree Grove. When the park department took over the land, there were many more of the old nursery trees, but they were removed to allow for more natural landscaping.

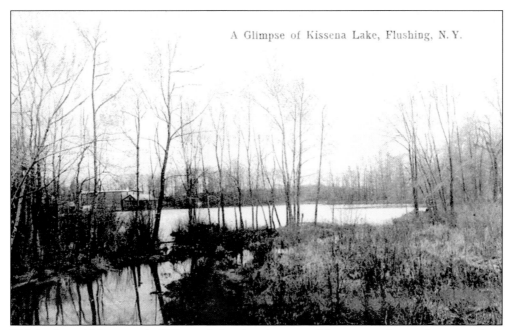

This is a beautiful postcard of Kissena Lake, showing one of the streams that used to empty into the lake. None of the streams can be seen anymore. Daniel Carter Beard, the famous illustrator and a founder of the Boy Scout movement, tells of going trout fishing in this area when he was a young man.

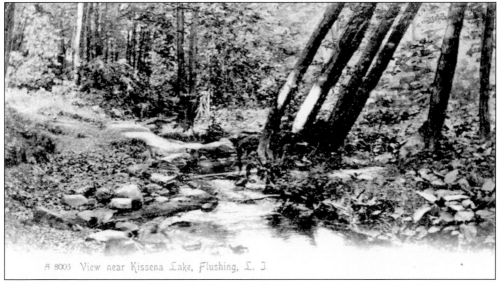

This postcard shows some of the wetlands south of the lake. In recent years, the New York City Parks Department has made efforts to restore some of this area, which had been neglected, and has established nature trails in the area.

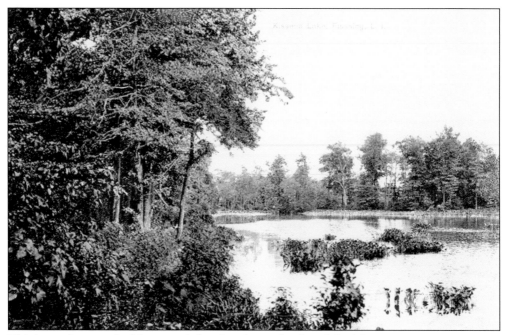

This is another wonderful postcard showing the wetlands and the lake.

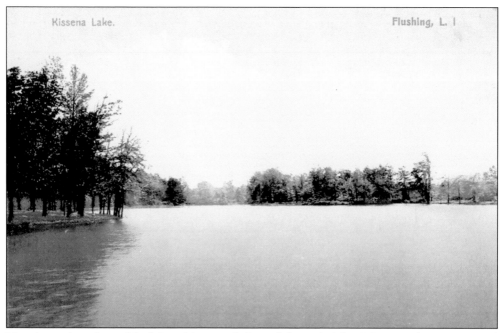

Here is another view of the lake with a good view of the main lake. It is not so large or natural looking today. In the last couple of years, the parks department has attempted to restore some of the shoreline to a more natural look.

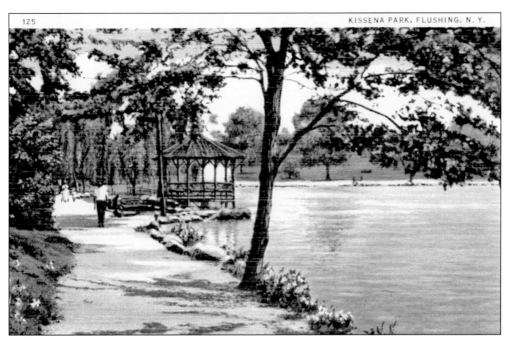

This shows a gazebo and the dirt path along the lake. When landscape architects started designing the park, they gave it a rustic Victorian look.

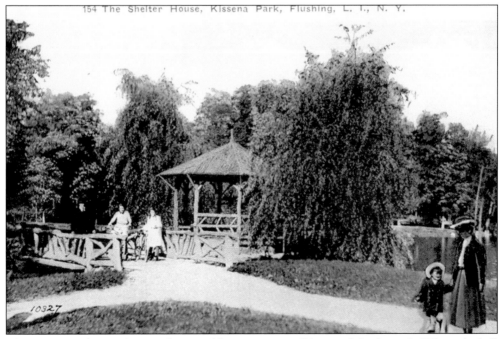

This appears to be another gazebo, possibly next to one of the ponds in the park. Where the ball fields are now located, there was a pond called Little Kissena Lake that was filled in long ago.

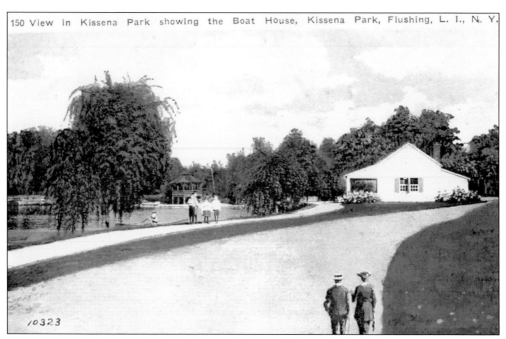

/0323

This is the boathouse on the lake. This wooden structure was torn down many years ago. Long after it was gone, it was still possible to rent rowboats on Kissena Lake, but the boats were docked on the opposite side of the lake near the rustic-looking structure that can be seen in the background.

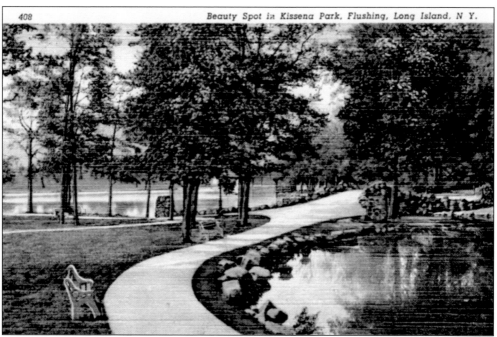

This postcard from the mid-1940s shows some of the surviving Victorian features of the park. The pond on the right was near the main entrance to the park at Oak Avenue. It was filled in shortly after this picture was taken, and a large modern playground was built in its place.

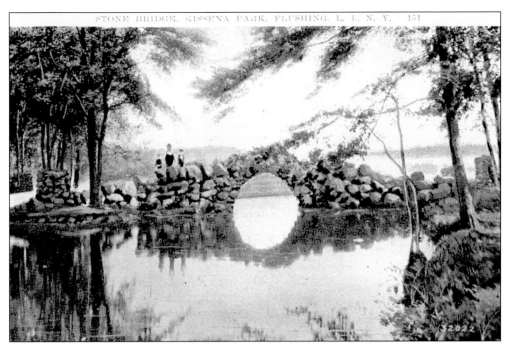

This postcard highlights the stone bridge that can be seen in the background of the previous postcard. This was torn down at the time the pond was filled in. This postcard gives a good idea of what was lost when much of the original design of the park was done away with to allow for greater use.

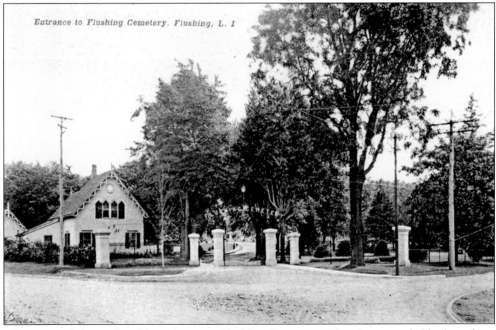

Entrance to Flushing Cemetery. Flushing, L. I

This postcard shows the old gatehouse at Flushing Cemetery. The picture probably dates from around 1910, about five years before that building was torn down and replaced by an attractive stone building that houses the cemetery offices and a chapel.

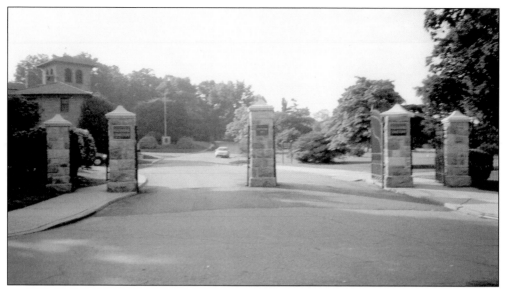

This recent picture shows the entrance to Flushing Cemetery today. Among the famous celebrities buried in the cemetery is Jazz great Louis Armstrong, who lived in nearby Corona.

This postcard shows an old stone house called the Sprong House that may date from the 1660s. The Sprong House was located on a farm that the cemetery acquired to expand its size in the 1870s. Sadly, it was torn down in the early 20th century.

Ten

CHANGES IN THE 1920S

A Flushing Business Association pamphlet of 1910 claimed that Flushing was the "premier suburban community" of New York City. This may have been an exaggeration, but there was much in Flushing that attracted the suburban commuter of that era. Flushing was still regarded as an attractive community with its mix of pre–Civil War and mid- to late-19th-century Victorian era homes and the newer ones going up in such areas as Murray Hill and Waldheim. With the completion of the Long Island Railroad tunnel beneath the East River, Flushing was less than a half hour from Penn Station. Newer suburban-like stations on Main Street, in Murray Hill, and on Broadway were being built or were already completed.

Much of what could be called old Flushing was still intact as late as the 1920s. Although the makeup of the population was changing, as more and more immigrants from Italy and other southern and eastern European countries were moving into the old village, many of the old families were still well represented (Bowne, Parsons, Murray, and so on). The old houses of worship—the Quaker meetinghouse, St. George's, St. Michael's, and the Congregational church—were still well attended. Changes in the look of the village were taking place. Main Street no longer looked like a small-town Main Street, but more like a modern shopping street. Apartment buildings started appearing in the community, along Northern Boulevard (no longer Broadway) and in other areas. Like many of the homes, the first apartment buildings were mostly for the upper-middle class and middle class. In the following decades, developers would build many more apartment buildings in Flushing. These early ones with their courtyards and their ornamental designs still stand out as something special.

The beginning of the end of old Flushing could be said to have started with the arrival of the IRT subway in 1928. The station at Main Street and Roosevelt Avenue opened that year. It now cost a nickel to go from Flushing to Times Square. Since 1915, the last stop on the IRT line (today's No. 7 train) was 103rd Street in Corona, the neighboring community to the west. The reason for the delay in reaching Flushing were the problems caused by World War I and, more importantly, the difficulties in traversing the Flushing Creek. The first attempt to build a trestle over the Creek collapsed because of the soft riverbed. The problem took builders years and a great deal of money to solve. Knowing of the effect it would have on local business, the leaders of the business community in Flushing had formed committees urging the IRT to complete the subway line. However, not everyone supported the idea. The famous illustrator and Boy Scout leader Daniel Carter Beard said he would move as soon as the subway reached Flushing. True to his word, he moved to upstate New York as soon as it did.

PRESIDE
APAI
FLUS

Among the first of the large apartment complexes to be built in Flushing were the President Harding Apartments near the intersection of Kissena Boulevard and Sanford Avenue, which opened in the early 1920s. This postcard appears to be an advertisement. The inset shows the central plaza. A

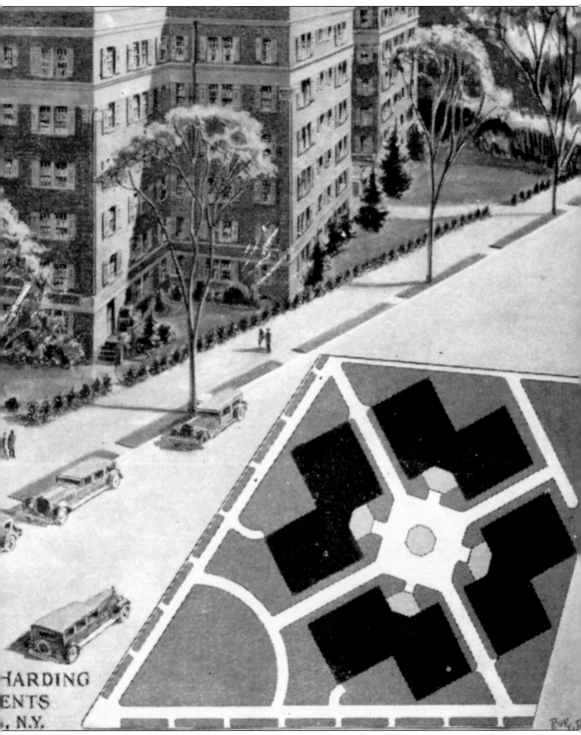

selling point was the great deal of open space in the complex. The expensive automobiles shown along the street seems to suggest the kind of tenants the owners were appealing to.

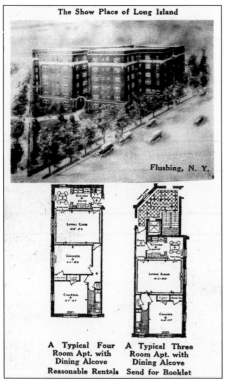

Another advertisement for the President Harding Apartments, this shows the outlines for a typical four-room or three-room apartment. Years later, many of the luxury apartment buildings in the area would subdivide most of the larger apartments into smaller units.

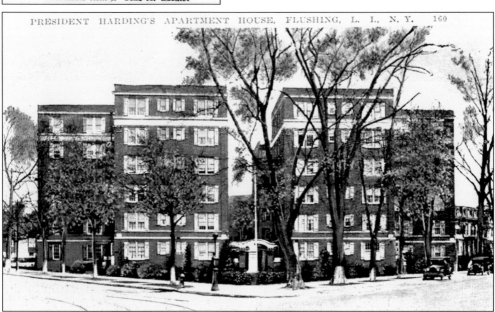

PRESIDENT HARDING'S APARTMENT HOUSE, FLUSHING, L. I., N. Y. 160

This postcard offers a street level view of the President Harding Apartments. The statue of Pres. Warren Harding can be seen on the pedestal in the front plaza. The apartments were probably named for Harding after he died, but before knowledge of his administrations scandals became well-known. In the 1960s, when the statue had to be removed because there was a danger of it falling, the apartment owners had a difficult time finding someone who would take it. It was finally sent to a museum in Harding's home state of Ohio.

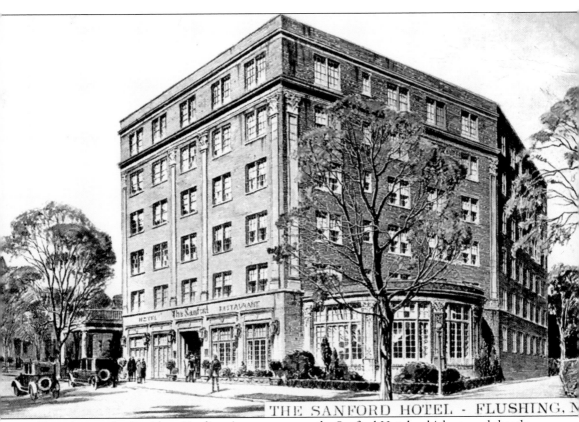

THE SANFORD HOTEL - FLUSHING, N

Next door to the President Harding Apartments was the Sanford Hotel, which opened shortly after the apartment building. In the beginning, it advertised itself as a residential hotel as well as a transient hotel. It was locally popular as a place to hold wedding receptions.

Hotel Sanford
Flushing, Long Island
New York

A more recent postcard shows that the hotel has lost some of its early luster. Flushing's nearness to LaGuardia Airport was good for business and, no doubt, extended the life of the hotel. It is now a welfare hotel.

The Good Citizenship League building was built around 1910. The league was a women's organization that fought for local civic reform. The building was used for meetings, lectures, art exhibits, and so forth. It was torn down in the 1960s. The Sanford Hotel was built next to the league building.

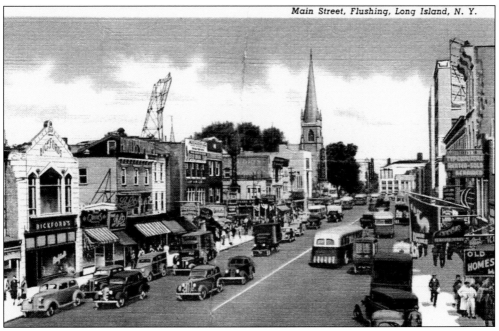

This is a postcard showing Main Street in the 1930s after it had become a modern shopping center. The RKO Keith Theatre can be seen at the top of the picture.

The RKO Keith Theatre was built on the old site of the Flushing Hotel on Northern Boulevard at the head of Main Street. It was one of three atmospheric movie palaces built in Queens (the other two were the Loew's Triboro in Astoria and the Loew's Valencia in Jamaica). In its first

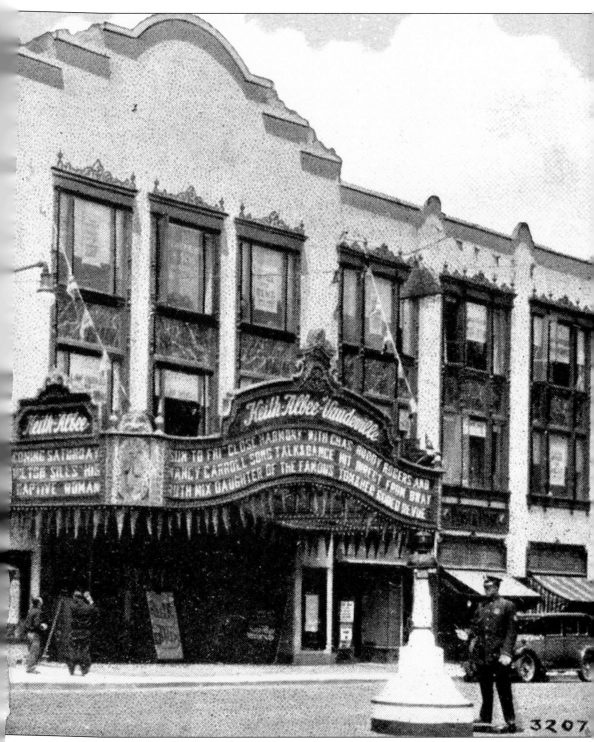

years, it hosted vaudeville shows along with regular movie shows. Bob Hope and Jack Benny played the Keith.

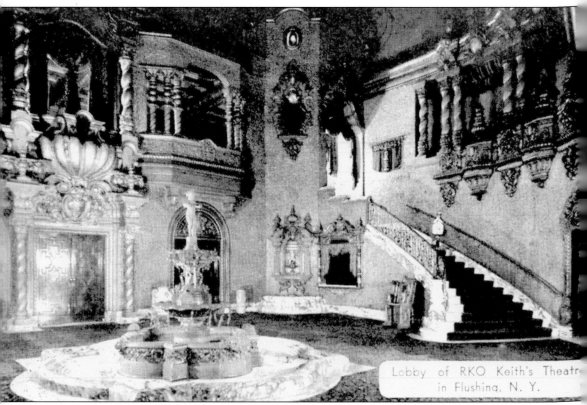

Lobby of RKO Keith's Theatre in Flushing, N. Y.

This postcard shows the interior of the RKO Keith Theatre. The Keith accommodated over 3,000 patrons and, in a way, was also a community center, hosting many high school graduations over the years. It opened it 1928. The current plan for the building is to build a new commercial and residential structure that will incorporate the theater's old ticket lobby and grand foyer, which are a city landmark.

The Flushing YMCA building at the southwest corner of Northern Boulevard and Bowne Street facing Northern Boulevard is shown in this postcard. There was a YMCA chapter in Flushing as early as 1859. This beautiful building opened in 1925.

"IO BOWNE AVENUE APARTMENTS" NORTHERN BOULEVARD, FLUSHING, L. I.

This apartment building was known as No. 10 Bowne Avenue. Notice the gatehouse at the front of the building. 10 Bowne Avenue was the old address, and it can still be seen in lettering on the north side of the apartment building.

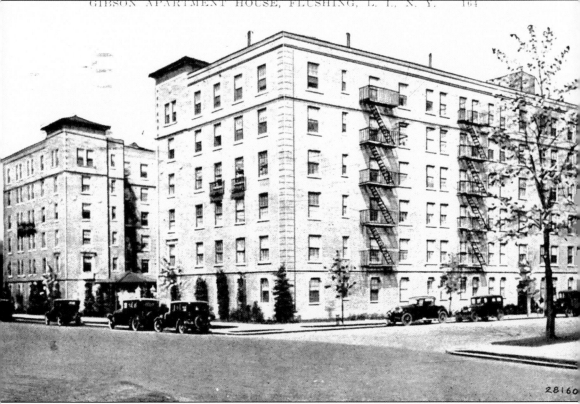

This apartment building, the Gibson, was similar in style to No. 10, and it too had a gatehouse near the front entrance. The Gibson's gatehouse is still there. The Gibson, which is on Northern Boulevard near 149th Street, was named for its developer and not for the creator of the Gibson girl, Charles Dana Gibson, who grew up in Flushing. However, Richard Outcault, the creator of *Buster Brown*, moved to this luxury apartment building shortly after it opened in 1925. The older tenants say that Chico Marx also lived here at one time.

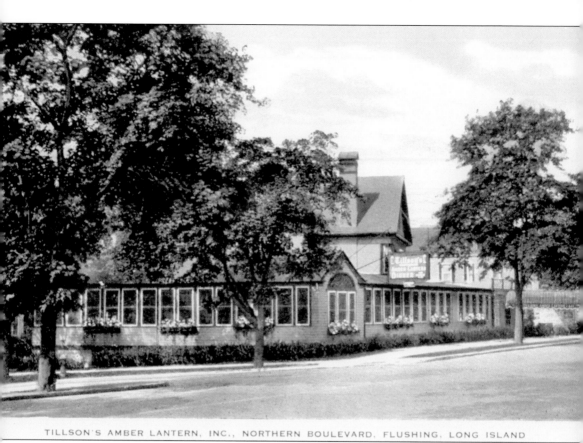

TILLSON'S AMBER LANTERN, INC., NORTHERN BOULEVARD, FLUSHING, LONG ISLAND

This is a picture of the Amber Lantern, a popular restaurant in Flushing, which opened in the 1920s and survived until the 1980s. It was located on Northern Boulevard near 150th Street.

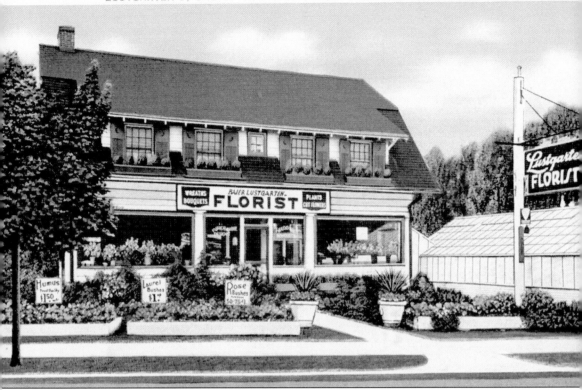

This 1920s postcard shows a lovely florist shop on Northern Boulevard and 159th Street. It was torn down years ago. There is still a Baier Lustgarten nursery located in Middle Island in Nassau County.

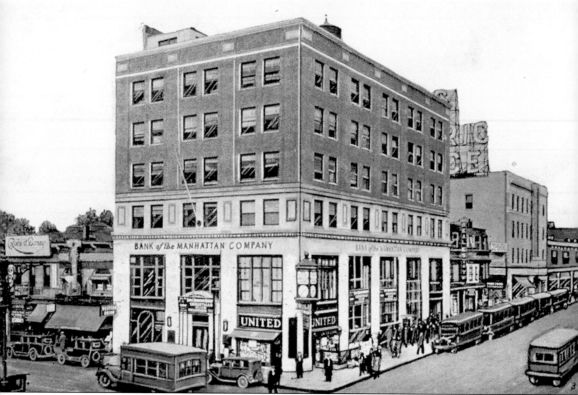

This is the intersection of Main Street and Roosevelt Avenue around 1930. The entrance to the Main Street subway station is shown. Many a young man or woman met their date beneath the large clock on the bank building on the northeast corner. The clock is still there, but it has not worked for years.

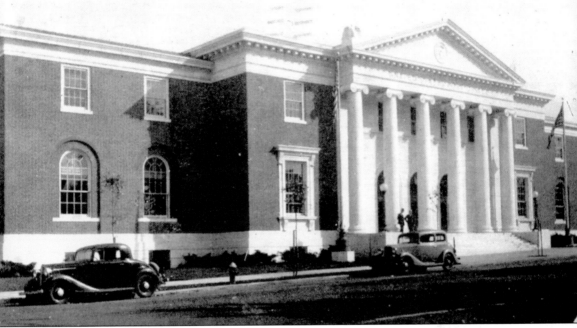

The main post office on Main Street opened to the public in February 1934. It is a couple of blocks south of the library on a portion of Main Street that used to be called Jaggar Street.

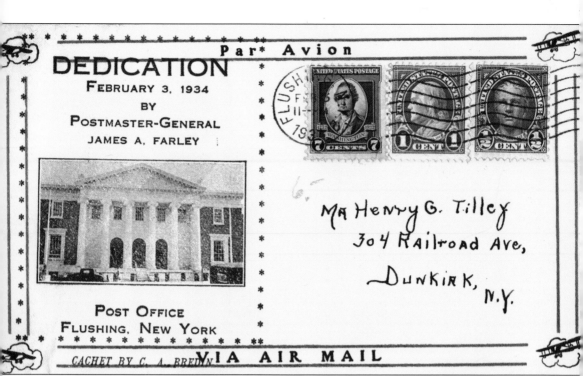

A new postcard celebrating the opening of the new post office is seen here. This is the main post office for much of what used to be the town of Flushing and not just the village area. Inside is an attractive Works Progress Administration mural depicting scenes from Flushing's history.